# NORTHWICH THROUGH THE AGES

Paul Hurley

AMBERLEY

# Acknowledgements

I would like to thank firstly the photographers of old who have left us with a marvellous archive of photographs, literally showing Northwich through the ages. To Ann Mcall and her hubby Lawrence who allowed me access to their impressive archive of photographs and postcards; without them this book would not have been possible. I would have struggled with some of the specialist knowledge of waterways and the ships built on the Weaver. This knowledge was provided by Colin Edmondson and Tony Barratt. Margaret Dutton of the Winnington Rec for her knowledge of this old and still successful club. And members of the growing Facebook group *Mid Cheshire Through Time* for their input and useful comments on my old photographs. All of the new photographs were taken by me. Finally my lovely wife Rose for her patience during the compilation of this book.

First published 2016

Amberley Publishing
The Hill, Stroud
Gloucestershire, GL5 4EP

www.amberley-books.com

Copyright © Paul Hurley, 2016

The right of Paul Hurley to be identified as the Author of this work has been asserted in accordance with the Copyrights, Designs and Patents Act 1988.

ISBN 978 1 4456 5385 3 (print)
ISBN 978 1 4456 5386 0 (ebook)

British Library Cataloguing in Publication Data. A catalogue record for this book is available from the British Library.

Typesetting by Amberley Publishing.
Printed in the UK.

# Introduction

Northwich has been an important settlement since at least Roman times. The salt beds of Cheshire deserve more than a quick mention as it is here in Northwich and the surrounding areas that the prosperity of the town was based in those far off days. During Roman times Northwich was known as Salinae or the 'salt works', and later by the Celtic name Hellath Dhu, or the black salt town by the Ancient Britons. Throughout these periods salt was dug out of the earth. Over the years mines were dug and later abandoned; two other towns had an abundance of salt beneath the ground and with Northwich became known as the three Wiches or Wyches of Cheshire, Northwich – Nantwich and the one between the two, Middlewich. Much is known of the subsidences in Northwich when wild brine was pumped and the voids that this left collapsed. In some part, for instance at Marston, the earth collapsed into abandoned mines causing devastation above. Some photographs of the result of these collapses are shown within.

J. Cumming Walters wrote in his book *Romantic Cheshire* in 1930,

Northwich transports us at once to a goblin-realm of topsy-turveydom, and the stranger who finds himself amid the slanting structures has an impression at the outset of being involved in a crazy adventure. The natives are, of course, accustomed to walls askew, to sunken basements, squinting windows and bulging roofs.

While the stranger was seeing these things, the people of Northwich were continually propping up their buildings and remaining in them. The so called Over prophet Nixon, or Nickson, foretold that Northwich would ultimately be destroyed by water and over the years it has suffered several floods. Now however vast sums of money are being spent by the Environment Agency to build a flood defence system that hopefully will prevent this prophesy from coming true.

Dipping back further into history we find that Northwich, or part of Northwich, was in the parish of Great Budworth, the church being St Mary's; the parish contained Castle Northwich, Hartford, Winnington and Witton cum Twambrookes etc. Witton church at the time was simply a chapel of ease dedicated to St Mary and All Saints at Great Budworth.

Castle Northwich is on the direct line of the road from Chester to Northwich and it is ancient. Old records show it as Castleton and Le Castele juxta Northwyche. There was a fortress there dating from AD 70, situated at the confluence of the Rivers Weaver and Dane. Nothing is left of the castle, but in the 1600s the location was believed to be a small field on the right-hand side of the Chester Road immediately above the Hollow-way. This would be what we now know as Castle Hill. Nothing is left of this today.

In *The History of the County Palatine of Chester* by J. H .Hanshall dated 1817, he writes 'Winnington Hall is described as a large building with nothing particularly striking in its

appearance; the situation however, is delightfully picturesque close to the most romantic part of the River Weaver.'

This was not to last long as two businessmen were later to alter this description completely. In 1873 John Brunner and Ludwig Mond formed a partnership and purchased Winnington Hall and its expansive grounds at Northwich. The hall was built in the late sixteenth or early seventeenth century for a member of the Warburton family of Warburton and Arley in Cheshire. In the early 1800s a sandstone extension was added. This beautiful country house later found itself not in the country but in the centre of an industrial complex. John Brunner and Ludwig Mond wanted the estate to build their chemical works, Brunner Mond Ltd, later Imperial Chemical Industries (ICI). Initially the plans were to demolish it but this was later rescinded and Brunner and Mond moved into it with their families. The hall has outlived most of the chemical works that once surrounded it. But Brunner and Mond became a limited company, building Winnington Works on the grounds of the hall and the first batch of soda ash was produced in 1874. Later called the ICI, it became one of the largest and most successful companies in the world. By 1986 it was the largest employer in Mid Cheshire. It is now part of the Indian Tata conglomerate.

Then there were the two riverside firms of Yarwoods and Pimblots, shipbuilders, both of which are mentioned further within these pages. Despite being on a river they both provided tugs, ferries, barges and small warships for use around the globe. One of the notable people to work at Yarwoods was Thomas Edward Lawrence, better known as Lawrence of Arabia, who worked on the design of RAF rescue launches to be built there for work rescuing downed pilots. In 1921 he was a full colonel and adviser to Winston Churchill. In 1922 he tried to enlist as an aircraftman in the RAF using a false name but was found out. He was later allowed to join, was exposed again and joined the Royal Tank Corps, again under a false name, in time being allowed into the RAF – his life was a roller coaster. He later came to Yarwoods to work on high-speed boats and died in 1935 as a result of a motorbike accident.

What Northwich is really famous for is the spectacular subsidences that occurred in the late 1800s and early 1900s. They were caused by wild brine pumping and resulted in Northwich buildings being rebuilt on steel girders allowing them to be jacked up and easily levelled again. Some of the new building benefitted the look of the town, buildings like the post office, now a Wetherspoons pub and the library built in what has become to be known as mock Tudor or Cheshire black and white.

This is a very brief look at Northwich through the ages, first salt, and then soda ash. The Lion Salt Works is a restored historic open-pan salt-making site that is now open to the public at Marston near Northwich and the old Workhouse, later the Salt Museum and now the Weaver Hall Museum and Workhouse. Both are well worth a look. Enjoy the book.

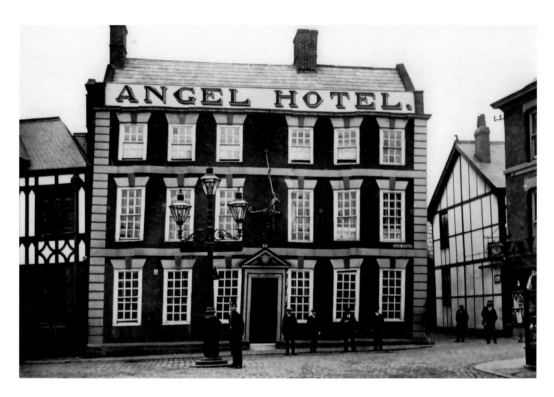

**Angel Hotel,** *c.* **Early 1900s and 2015**
This ancient hotel had the address No. 10 High Street and was opened in 1763 facing into the Bullring. It was once an important coaching inn that, in the early 1800s, saw the 'Rocket' arrive at 9.30 a.m. every morning from Liverpool to Wolverhampton. The 'Nettle' from Nantwich to Manchester and other regular coaches. Many VIPs of the day would pass through its doors, one being the future queen, Victoria. The first landlord in 1763 was Francis Hansall and the landlady who took the pub through the First World War, from 1914 until it closed in 1921, was Emily Edwards.

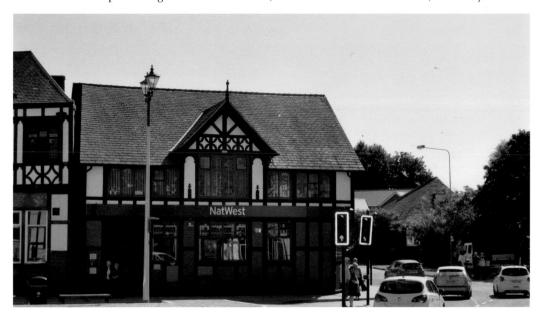

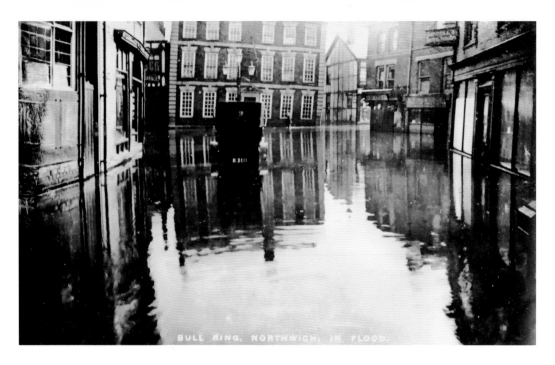

**The Bullring and Angel Hotel in a Flood,** *c.* 1920s and 2015
The hotel suffered several floods in the area, one of which can be seen here, but stood solidly with waterlogged cellars and ground floor. What it was unable to fight was the subsidence that Northwich almost uniquely suffered. In respect of this hotel, it has been well documented in photographs as the windows started to sag and the large building slowly succumbed to the unstable ground, finally being demolished in 1921 to make way for the bank that is seen in the modern photo. The Bullring was the scene of many large gatherings and the Angel formed the background to them.

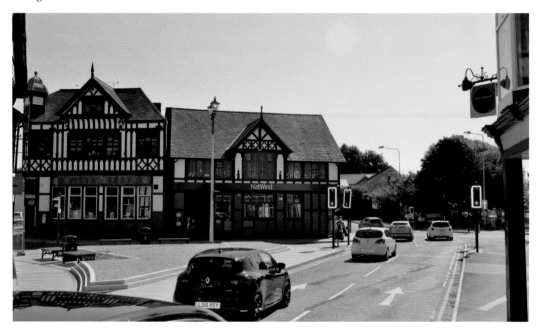

## Ye Olde Turks Head Pub and the Site in 2015

This little old pub was in the directory for 1828 when J. Pickering was the landlord and the address was Market Place. By 1896 it was still shown with Samuel Shirley at the helm, but now the address was No. 10 High Street. The building in its place today houses Temples Property Management at No. 10 The Bullring. This gives us an insight into the changing names of this area; note the original address of The Angel Hotel. In 1896 its address was simply High Street; it was later that the Bullring name became popular.

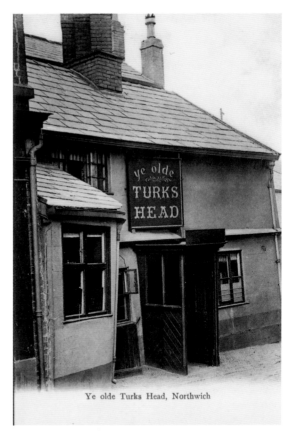

Ye olde Turks Head, Northwich

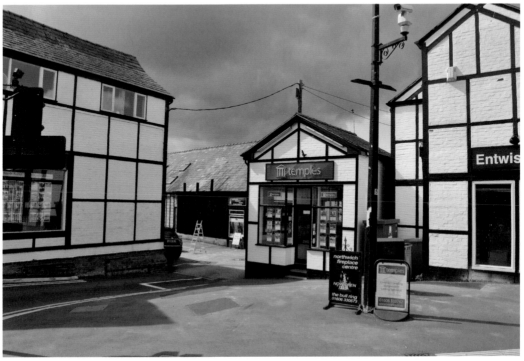

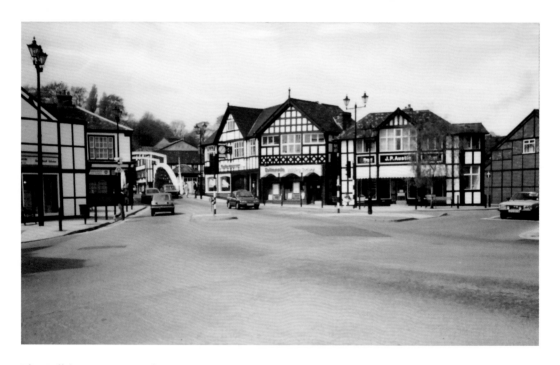

**The Bullring,** *c.* **1980s and 2015**
One of the areas of Northwich that has seen a lot of change in 2014 and 2015. Note the additional ornamental paving on both sides of the road and the one-way system in operation. Buildings have been demolished to make it wider. The name Bullring originated in the days when bull-baiting was a sport, with savage dogs baiting the bulls for the entertainment of a baying crowd.

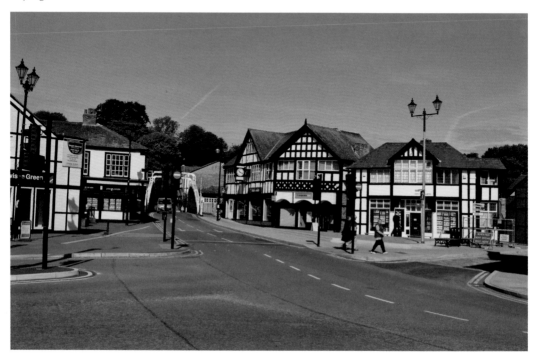

**Bostock's Shop undated, and the Site in 2015**

This old shop was a feature of the area for many years; in 1896 it was situated on the corner, roughly where the Wright Marshall premises are now, with the address No. 4 The Bull Ring, High Street. Bostock was a very common name in Northwich and Mid Cheshire at the time.

This Bostock in 1914 was Algernon Ralph Bostock who was recorded as a watchmaker, but as this advert for the premises shows he dealt in other goods such as Goss china, which is very fine china, usually in the form of miniature models and family crests.

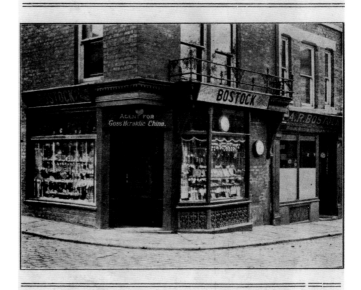

# A. R. BOSTOCK.

## 14, 16, Bull Ring, NORTHWICH.

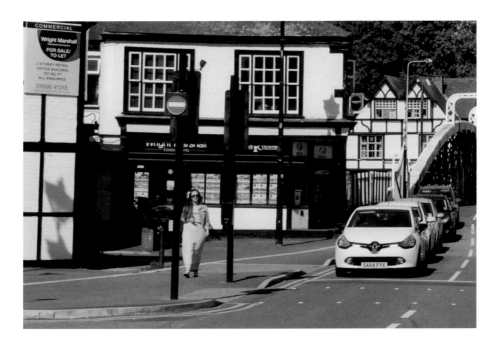

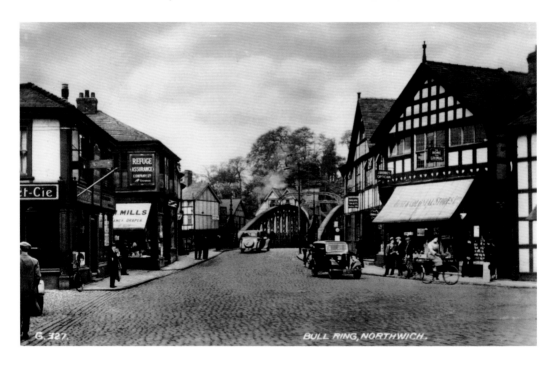

**The Bullring,** *c.* **1950s and 2015**

A similar view to earlier ones, but one that gives the opportunity to view the scene as one would in the 1950s, with two cars of the period. Now the old shop houses Mills Fancy Draper and the district office of the Refuge Assurance Co. where Gershon Anderson was the superintendent. The address of this building is shown as No. 6 High Street; that of the far right is No. 8, which houses Estelle et Cie hairdressers.

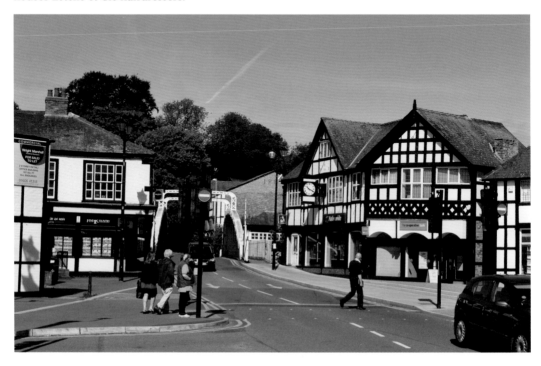

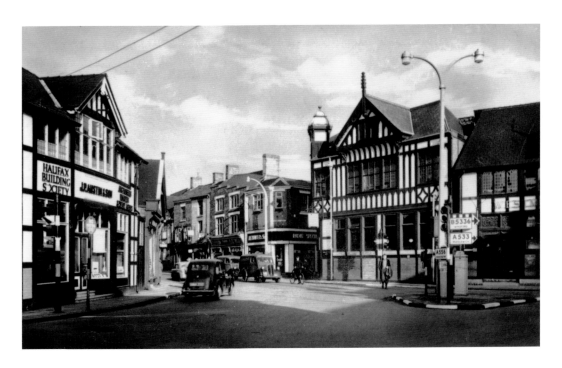

**Bullring into High Street, 1957 and 2015**

From the Bullring into High Street showing the building that had to be lifted and the lower floor rebuilt when it was a bank. Since then it has had several uses, the last being a restaurant, and it is now in the course of refurbishment prior to its next reincarnation. On the left is the long-standing estate agent's office of J. P. Austin. This is another good example of the changes being made to Northwich.

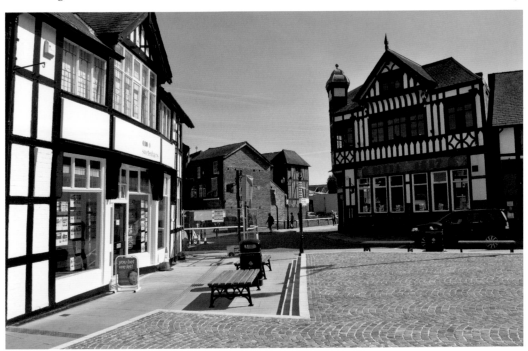

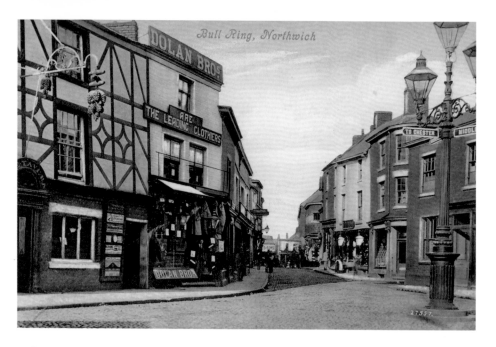

## Bullring, 1890s and 2015

The modern photograph was taken in August 2015 when a considerable amount of building work was taking place in the High Street. The old photograph has been hand tinted to use as a postcard and shows the Dolan Brothers store on the left. This store was demolished to allow for the road to be driven through to become Weaver Way leading to Barons Quay, once an area of poverty, hardship and poor housing. On the near left of the old photo is The Vine Tavern. The trustees of the Winnington Recreation club would hold their general meetings here. In the far distance in the modern photo, work can be seen underway in the new Barons Quay development.

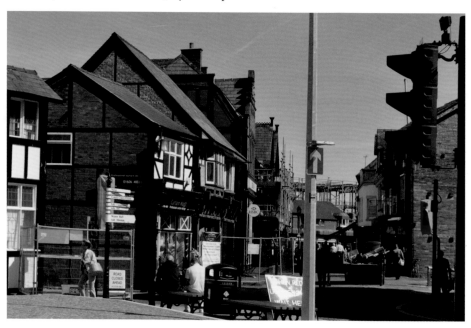

Willett's Stores, and Fred Worsley's, dated 1896
Rather than take photographs of scaffolding, as seen in the last pair of images, I thought I would treat you to some old adverts. The first one is for Willett's Stores, No. 21 High Street. This was the premises of Joseph Willett, a hosier and draper whose shop was the local depot for the Bible Society. The second is for Fred Worsley's, No. 17 High Street, a general draper and purveyor of ladies' and gentlemen's accoutrements. Looking at the photo, there have been some alterations to the premises although the address has remained the same.

# WILLETT'S Stores,

### Hosiery, Smallwares, Wools, Gloves, Haberdashery, &c.

Hardware, Cutlery, Brushes and Combs.

FANCY GOODS.

*Bible Society's Depot.*

## 21, High St., Northwich.

F

## WEAVER HOUSE DRAPERY STORES.

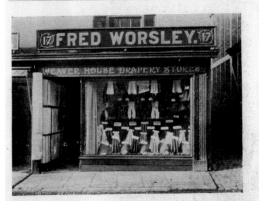

Hosiery, Calicoes, Family Linens. Sheets, Sheetings, Blankets, Quilts, &c.

DRESS GOODS IN ALL THE NEW MATERIALS.

Ladies' & Children's Jackets, Water= proofs, &c.

GOODS AT THESE STORES ARE SOLD AT THE — LOWEST PRICES. —

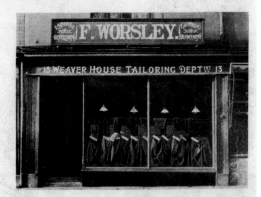

# FRED. WORSLEY,

*Ladies' and Gent's Tailor - and Woollen Draper. -*

17, High Street, Northwich.

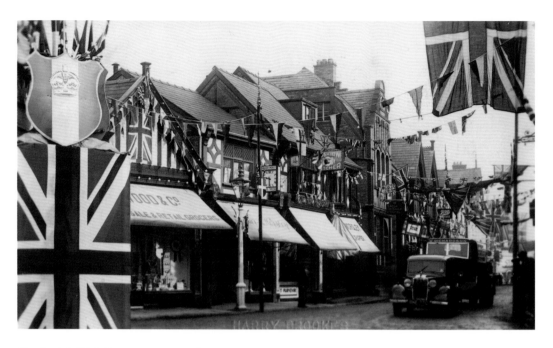

**Northwich High Street,** *c.* **1937 and 2015**
This view is of the High Street, taken during (what I would deduce as being) the festivities for the coronation of King George VI and Queen Elizabeth. Bunting fills the street and near to the camera is a king's crown. The car, which I think is a Vauxhall 14 model J, seems to be getting hassled by the wagon as it passes The Eagle and Child hotel, which can be recognised by the sign prominently displayed. Margaret Cheadle was the landlady and would remain so for a few more years until the pub would be closed and turned into a bank, the licence transferred to the new Beech Tree at Barnton.

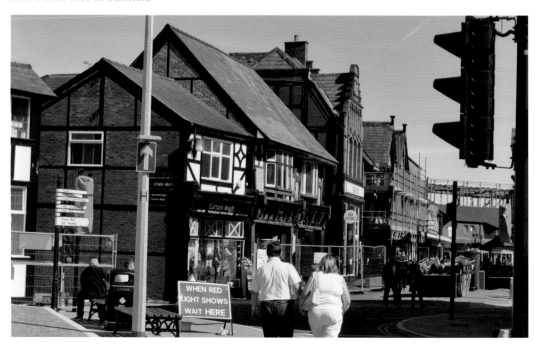

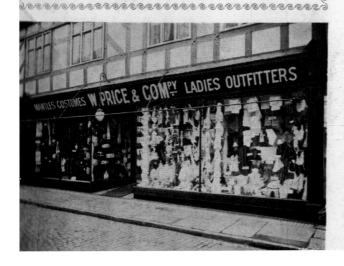

# W. Price & Co.

## Up-to-Date Drapers.

Agent for **Achille Serre, Dyer and French Cleaner.**

MANTLES AND COSTUMES A SPECIALITY.

## DRAPERS, DRESSMAKERS, MILLINERS, HOSIERS, GLOVERS.

Each Department worked on the most modern ideas, under experienced hands.

## High Street,
### NORTHWICH.

**W. Price's Shop, 1896, and Nightclub Madison's Today**

The archive photograph is of the large store W. Price & Co., ladies outfitters and undertakers, selling gas mantles to light the way! It was a large department store in competition at the time with H. Bratt & Son, which had been opened in 1860 by Mr Henry Bratt and was further up in Witton Street. The building has now been rebuilt and houses the nightclub Madison's and possibly the TSB Bank next door.

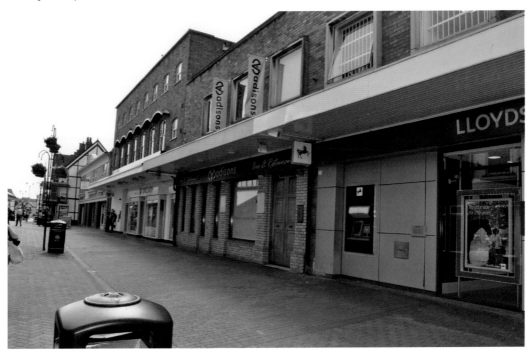

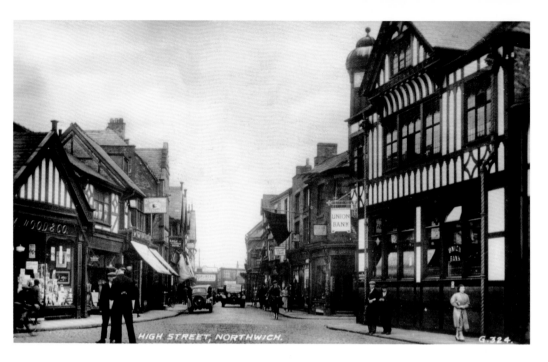

## Bullring into High Street, *c.* 1930s and 2015

A last look into the High Street as a policeman in a shako helmet holds a discussion with a member of the public. The bank building has its sign, Union Bank, displayed. On the left, the car with the spare wheel on view is parked outside the Eagle & Child pub. In the distance the road bears right becoming Witton Street. On the far skyline of the modern photo is the ongoing work to completely transform the Barons Quay area into a waterside leisure and retail development. The people of Northwich and surrounds are in for a treat.

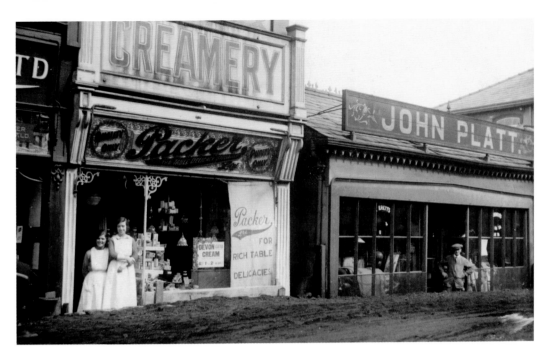

**Packer Creamery with John Platt Standing Outside,** *c.* **1900 and the Site Today**

Here we see another example of the subsidence that occurred in Northwich. The photograph shows the dairy produce store of Packer's and next door the saddlers of John Platt at No. 49 High Street. Both shops have simply slid into the ground since. There appears to be no fear of danger at this point however as the dairy staff stand in the doorway for the camera, as does Platt. The shops have now been demolished and replaced by what some may call a concrete monstrosity; others may describe it as simply the fashion at the time of building.

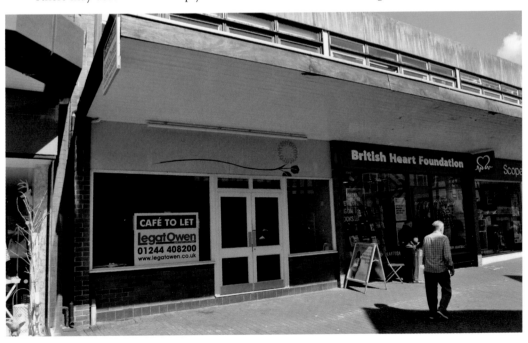

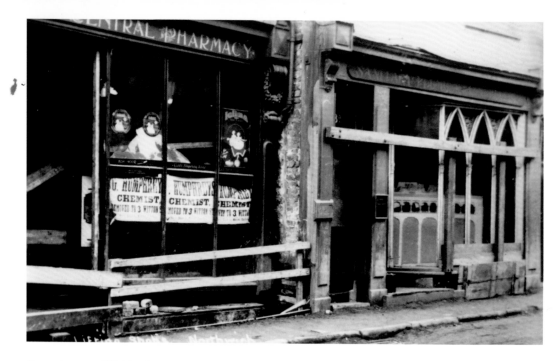

**Humphreys Griffith's Chemist, 1896, and Colby Conduct, 2015**

Here we see the old premises of Humphreys Griffith's pharmacy at No. 48 High Street. Unlike John Platt and the dairy next door, seen in the previous photograph, the chemist moved out just several doors away, to No. 3 Witton Street – probably to a building that had not yet succumbed to subsidence. The inset image shows the site of the building that they moved to. Looking at it, it would not have lasted that long as a modernist building now occupies the site. The photograph, taken in 2015, shows the location of the original building, now the site of estate agent Colby Conduct.

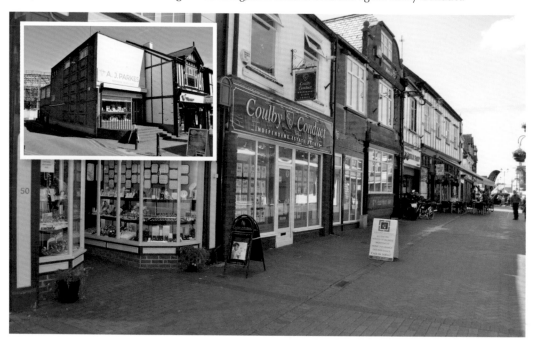

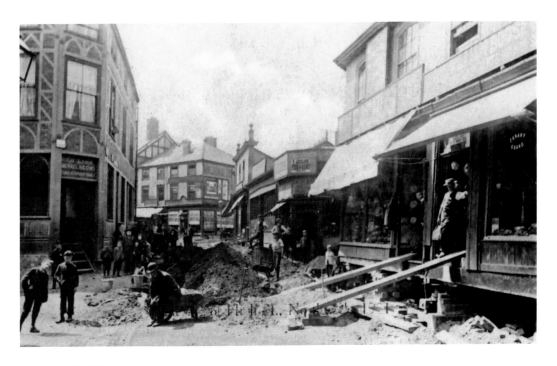

**The Red Lion, *c.* 1890s and 2015**
Into Witton Street now, this photograph looks back towards the High Street and the Crown Street junction, as work to lift some shops after they have subsided is in progress. The pub on the left is the Red Lion; the landlord at this time was Michael Higgins. The modern photo shows that although the pub was not demolished, it was substantially altered – the front elevation certainly illustrates this. It has gained the very popular mock Tudor black and white, rightfully very popular at the time.

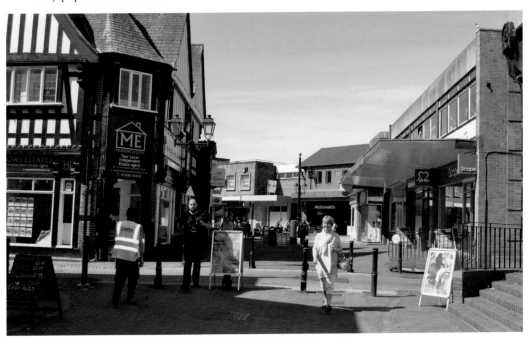

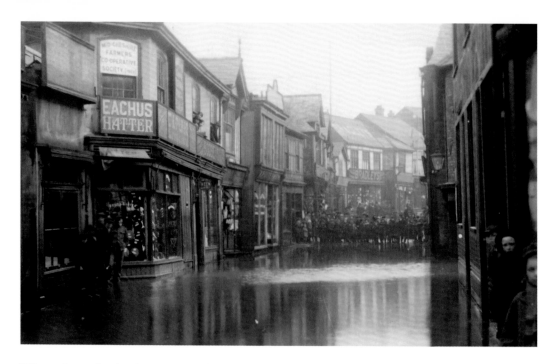

**Witton Street in Flood,** *c.* **1920s and 2015**

This photograph shows the junction now. Here is another example of Northwich's relatively frequent floods. The photograph is taken looking up Witton Street where the water has reached its level, leaving the Bullring, High Street, and the rest of the town low enough to suffer. As previously mentioned, £2 million is being spent on flood defences to prevent this happening again.

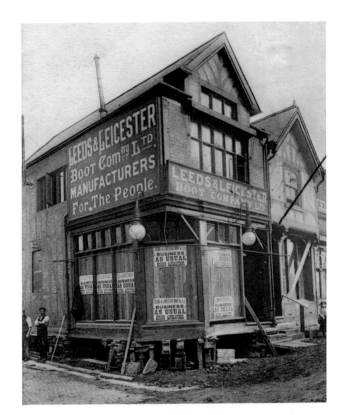

**The Leeds and Leicester Shop in Witton Street, Turn of the Twentieth Century and 2015**
By the 1920s the name for this shop had become Wyle's Bros Ltd boot and shoe manufacturers. When photographed here though it went by the name The Leeds & Leicester Boot Co. The shop had suffered from subsidence and, when photographed at the turn of the century, was in the process of being jacked up. As can be seen in the modern photograph, it did work as it still stands in Witton Street and is still a shoe shop.

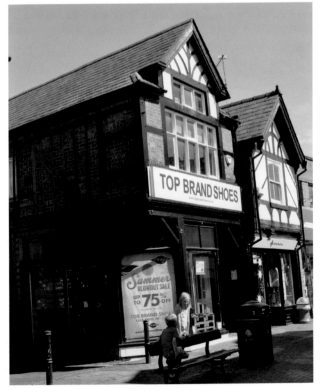

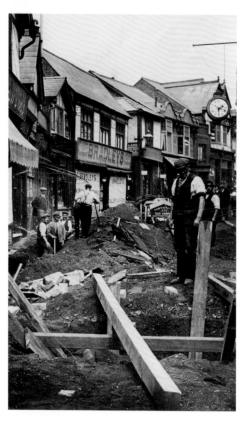

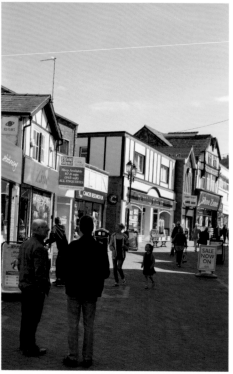

**Witton Street, 1912 and 2015**
Not subsidence this time, although the damage caused to the pipes and other accoutrements below the road probably led to this work. The above shows a photograph taken in July 1912 as workmen dig up Witton Street to maintain and replace the gas mains. One of the small trailers has 'Northwich No. 1 Gas Company' written on it. Bradley's tailors have remained open and the famous clock belonging to Elam's clockmakers looks down upon the work.

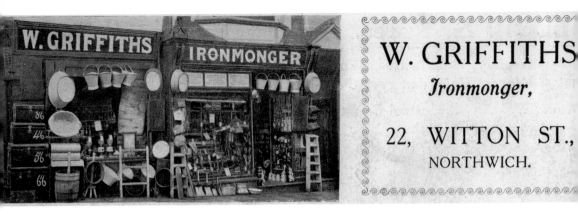

# W. GRIFFITHS

*Ironmonger,*

## 22, WITTON ST.,

### NORTHWICH.

**Pound Bakery, Griffiths Ironmonger at the Turn of the Twentieth Century and in 2015**

This is an advertisement for W. Griffiths & Co., an ironmonger that was situated at No. 22 Witton Street, opposite Leicester Street. At that time, 1896, it was located on the junction that led to a timber yard. It now leads into Northwich Weaver Square and market. The building has now gone and been replaced with a 'modern' one that houses the Pound Bakery. The Old Ship Hotel was next door, across the entry at No. 24. This shop would shortly relocate to premises in Leicester Street, where it could be found in 1928.

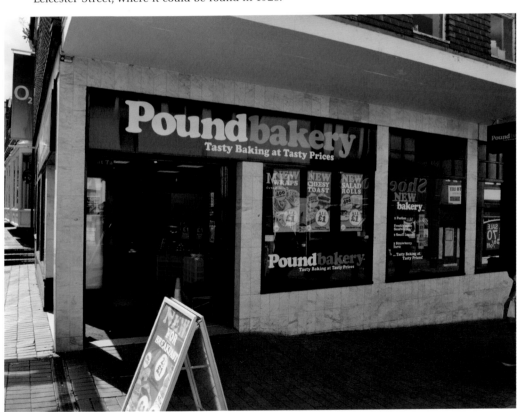

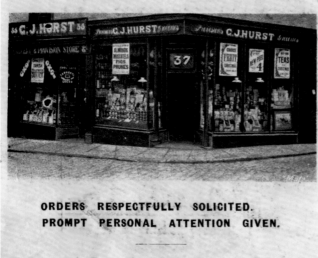

# G. J. HURST,
## Grocer, Tea Dealer & Provision Merchant.

ORDERS RESPECTFULLY SOLICITED.
PROMPT PERSONAL ATTENTION GIVEN.

*35 and 37, WITTON STREET,*
*NORTHWICH.*

**G. J. Hurst, Late 1800s and 2015**

Here we see the Witton Street premises of George Jacob Hurst that was situated at Nos 35 and 37 Witton Street, although that building has now gone and been replaced with a modern flat-roofed one. There was a provisions dealer at premises on the corner of Leicester Street, which led to the railway marshalling yards at Barons Quay and many examples of substandard housing. The modern building on this site now houses the Vodaphone telephone dealership.

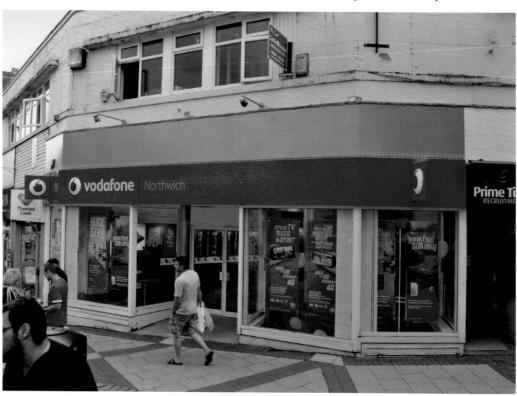

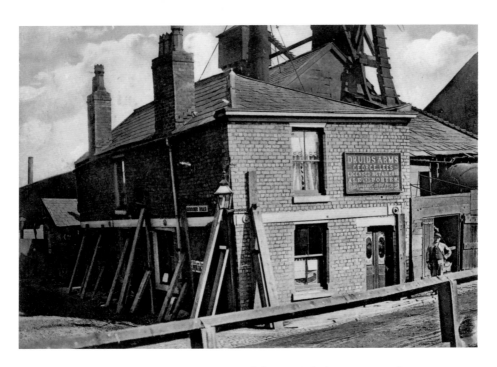

**Druids Arms, Leicester Street, at the Turn of the Twentieth Century and 2015**

This pub was situated at the junction of Gibson Street and Leicester Street and, if you look carefully, you can see its downfall in the form of a collapsing salt mine. Gibson Road was another road that led to Barons Quay and the railway there. It seems strange to have a mine in what was the town centre, but there were in fact four mines in that location: Barons Quay, Witton Bank, Penny's Lane and Neumann's Mine. All four mines were infilled and stabilised after a grant of £32 million by English Partnerships and made safe prior to the work that is now underway to regenerate Barons Quay.

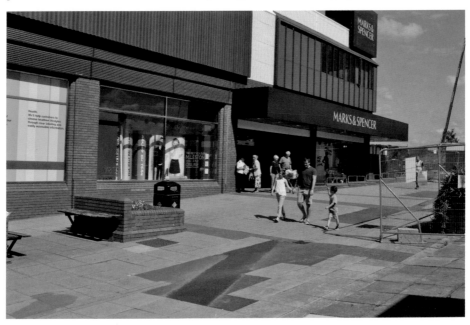

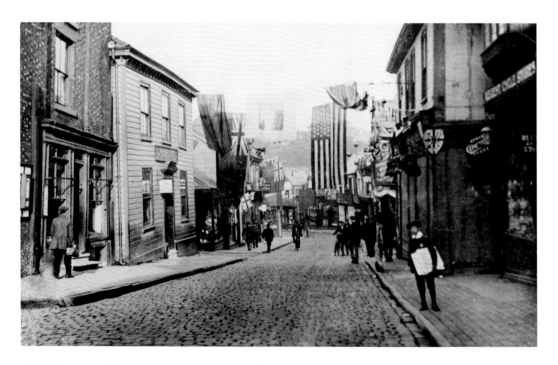

**Old Ship Hotel, Witton Street, Late 1800s and 2015**
Here we have evidence of just how much Witton Street has changed over the years. In the old photograph, taken at the end of the 1800s, bunting flutters in the street – quite possibly to celebrate the Diamond Jubilee of Queen Victoria in 1898. The Old Ship Hotel, with its ship-like clapboard cladding, is seen on the left. The building was later demolished and rebuilt in various guises including as a branch of Marks & Spencer and, as seen in the photograph from 2015, as Clinton's Cards.

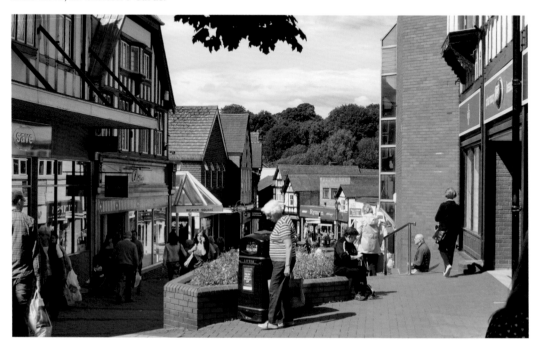

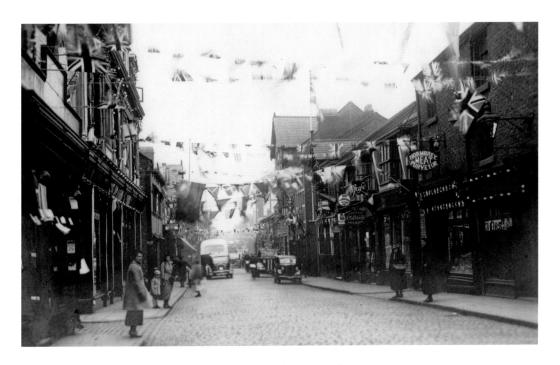

### By Hormbrey's Butchers, Witton Street, mid-1900s and 2015

This photograph is taken at the top of the slight rise in Witton Street with Hormbrey's butchers seen to the right. I would estimate the date as possibly 1937 – the year of the coronation of George VI and Elizabeth. Witton Street is still paved with stone setts. On the left there is a Wilderspool Ales sign that is affixed to the White Lion. All that is left of that pub now is a hole in the ground. This is certainly a snapshot in time and in the modern photos there has been a lot of change and rebuilding.

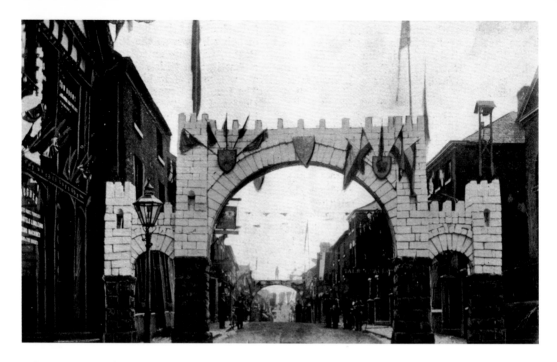

## Witton Street, Salt Arch Area, Late 1800s and 2015

Still roughly in the same area as the last set of photographs, though this one is a lot older. I would estimate it as dating from the later 1800s and shows a celebration of some sort once again; this one is probably for Victoria's Jubilee. With Northwich's history of salt mining, it was a tradition to build a celebratory arch out of salt blocks. The location is at the top of the rise in Witton Street and the window of the chapel can be seen far right. The next building along is the Talbot Hotel. There is another arch further on.

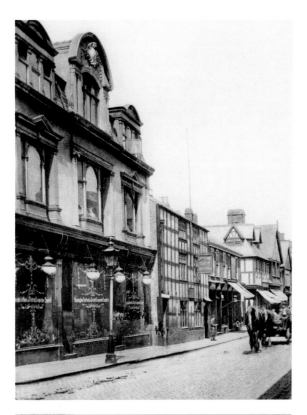

## Site of the Witton Street Co-operative Stores, c. Early 1900s and 2015

The Co-operative Society was founded by the Rochdale Pioneers in 1844; the rules of the society were based on the 'Rochdale Rules'. These outlined the proposals such as sharing the profits in the form of a dividend known colloquially as 'The Divi'. In 1863 the Co-operative Wholesale Society was formed, better known as the CWS. Many towns, large and small, had their own Co-operative Society, and the one shown here was the part of the Northwich & District Co-operative Society Ltd and was a department store. Note that little has changed over the years; the sets have gone with their fragrant horse droppings. The White Lion next door has also gone, but the hole remains.

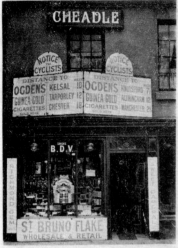
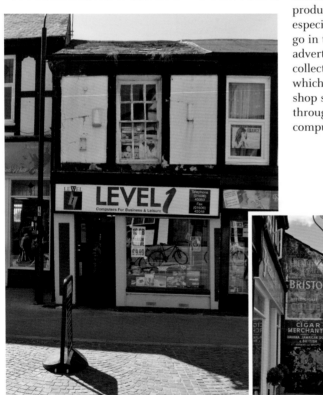

**Cheadle's Tobacconist undated and 2015**

Now here is an iconic Northwich shop that dates from the days when all forms of smoking were accepted and used by the majority. The smell in Cheadle's shop in the '50s and '60s was truly memorable, with tobacco products from around the world – especially to schoolboys who would go in to beg for 'dummies' (dummy advertising packets to add to our collections). Note the inset image which shows the gable end of the shop still showing advertisements through the ages. It is now a computer shop.

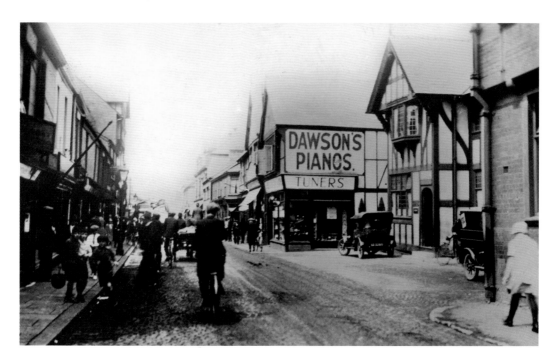

**Dawson's Pianos, *c.* 1920s and 2015**

This photograph looks back out towards the town centre from the area of Cheadle's shop and past the library. In this photograph, which I would estimate as being from the early 1920s, Dawson's piano tuners is seen next to the library. For many years this was the go-to shop for everything musical. No longer in Northwich, but still going strong, the company now has eleven Dawson's stores around the country. Music in Northwich is still catered for by the Northwich Music Centre in London Road.

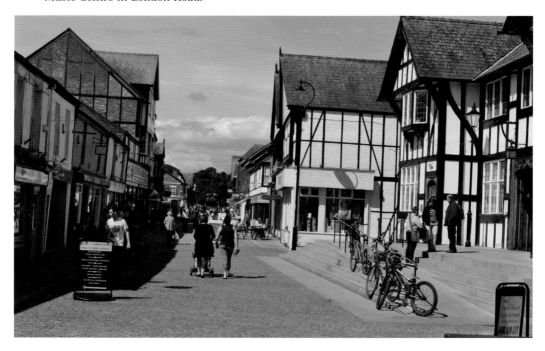

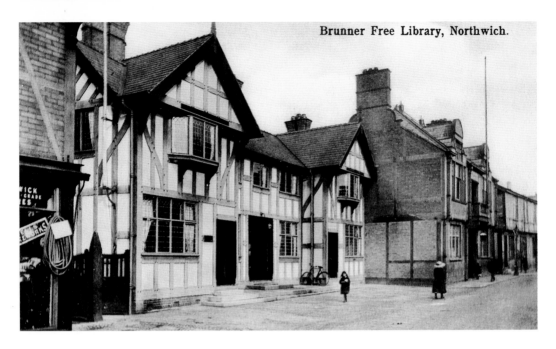

### Northwich Library, *c.* 1910 and 2015

Northwich library has had a chequered history due to the subsidence suffered in the early portion of the twentieth century. In 1887 Sir John Brunner presented the first library, which can be seen below. By the turn of the century however, after existing for less than twenty years, it had to be demolished due to subsidence. In 1909 the one shown above was built using the most technologically effective method for the time: a wooden frame sitting on iron girders that could be jacked up in the event of further subsidence. This style of building also greatly improved the look of the town wherever it was used. The inset photograph shows the library today

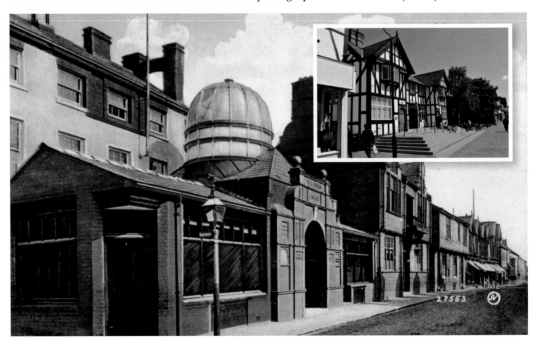

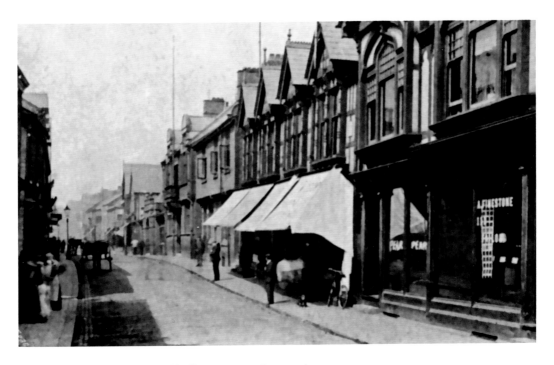

**Witton Street by the Old Library, Late 1800s and 2015**
A look at the area now taken before the demolition of the first library, which dates the photograph to the latter years of the 1800s, before the short-lived library was demolished. Not the best old photograph, but it provides a good view of Witton Street as seen in days gone by when the cameraman was unable to get the pedestrians to stand still for long enough to prevent the ghostly apparitions.

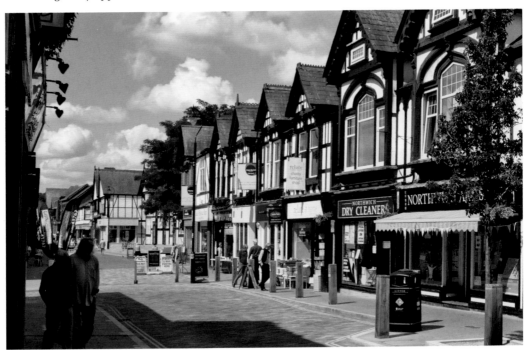

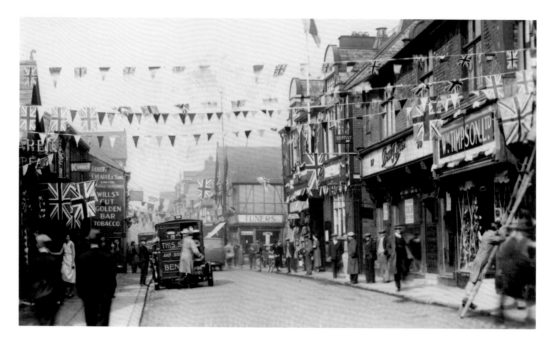

## Area of Cheadle's Shop and Library, c. 1953 and 2015

Still in the same area but forward in time to probably 1953 – the time of a coronation looking at the prolific bunting. It gives us the opportunity of seeing again Cheadle's gable end with its earlier adverts. W. Timpson Ltd boot and shoe manufacturers can be clearly seen on the right; this shop appears in the 1929 directory as being at No. 99a Witton Street. In the new photograph the junction with Meadow Street can be seen. Little has changed on the left from the archive photograph, but we can see that the building on the right with the rounded roof windows has gone.

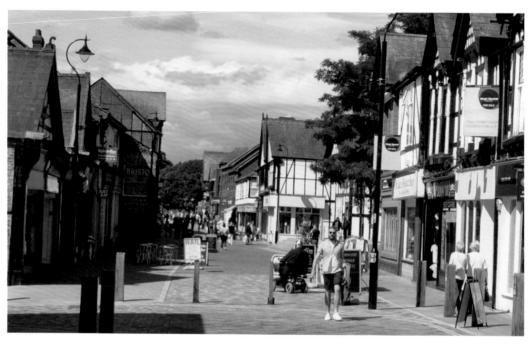

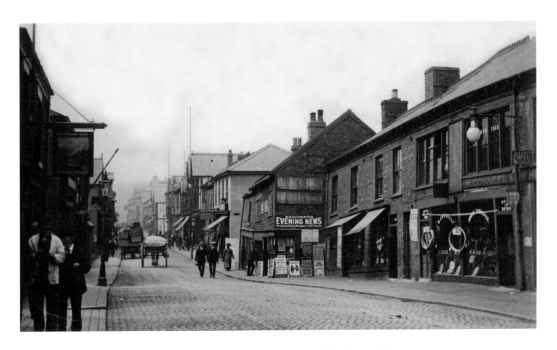

**Waterman's Arms, *c.* Turn of Twentieth Century, and Witton Chimes, 2015**

We carry on further up Witton Street until we come to the Waterman's Arms. This pub has had a few names but is still open and called Witton Chimes. The photograph can be dated quite accurately to the turn of the last century as one of the many advertisements on the wall in the old photograph is for Harry Lauder, later knighted, who was a well-known Scottish music hall singer and comedian. He was born in 1870 and died in 1950. Witton Street is paved with setts and subsidence had started, resulting in buildings on the right from the cream building next to St Pauls Place, being replaced.

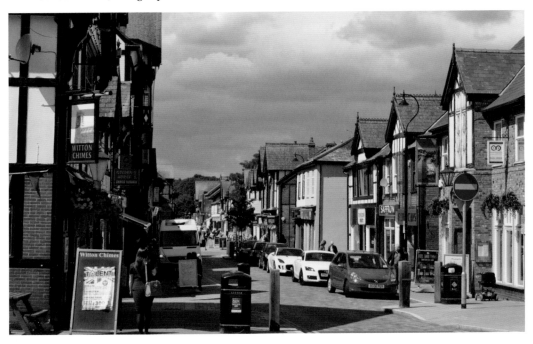

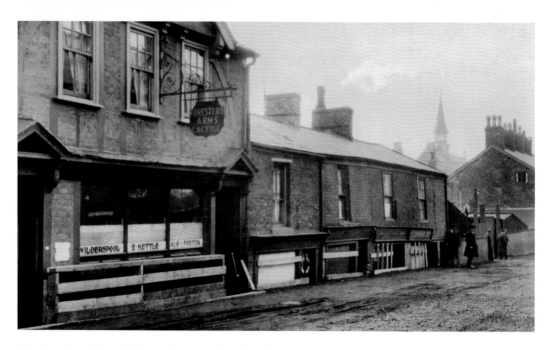

**The Foresters Arms, Witton Street undated, and 2015**

Here is an excellent example of the subsidence that Northwich was famous for. The Foresters Arms existed from 1861 to 1932. The landlord at the time this photograph was Eddie Kettle who was the incumbent from 1909 to closure. This was a time when there were many pubs in Northwich, unlike today when the town is going through a period of closures. In the old photo here we can see the spire of St Wilfrid's church in the distance. This was then a busy area and well built up. As can be seen, it was in a place of much subsidence and today, apart from the Green Dragon pub on the other side of the road, all old buildings have gone.

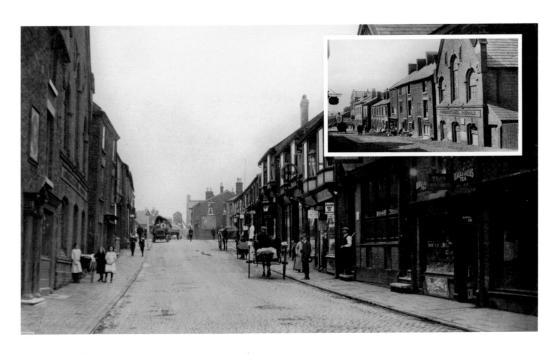

### Top of Witton Street, Early 1900s and 2015

In this pair of photographs we are looking at the Foresters Arms from the other side, before it subsided. Eddie Kettle is still the landlord at this point. The photo is dated by the motor lorry (seen at the top) to just before the First World War. What a good example of just how busy the top of Witton Street was then compared with today. In the upper portion of the old photograph the road can be seen changing to Station Road. Further up on the right is the Cock Hotel, which was eventually replaced by a new Cock Hotel (now closed). On the left are the Lord Nelson pub and the Congregational schools that subsided spectacularly, as seen in the inset photograph.

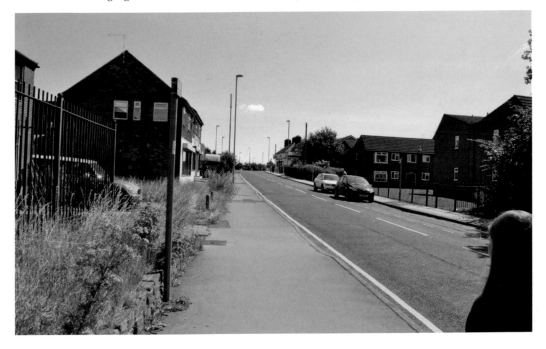

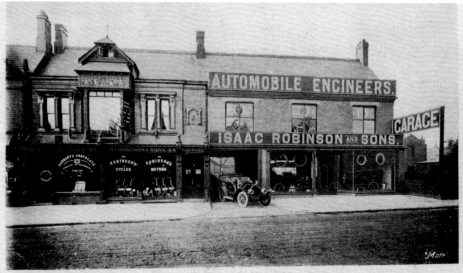

AUTOMOBILE ENGINEERS.

ISAAC ROBINSON AND SONS.

GARAGE

ROBINSON'S CYCLES    ROBINSON'S MOTORS

"Mate"

SAAC ROBINSON & SONS, Station Rd., Northwic
CHESHIRE.

### Isaac Robinson's Car Dealership, Station Road, pre-First World War and 2015

Another look now at an old advertisement, this time for period motor cars. Here we see one of the pioneers of the internal combustion engine as Isaac Robinson sells his motor cars and motorcycles with names now consigned to classic vehicle shows. The garage address is Nos 42–44 and No. 46 Station Road. The modern photo shows that a car sales premises still exists in the vicinity. I would imagine that old Isaac would be amazed if he saw the cars for sale now in the place where he once sold his.

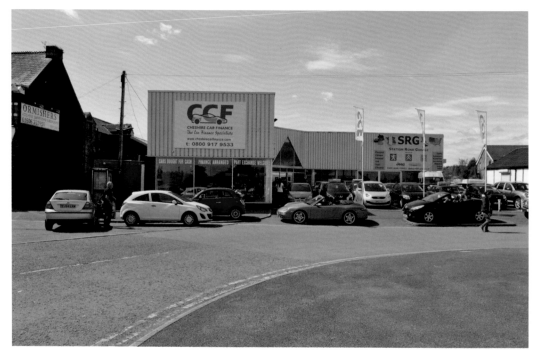

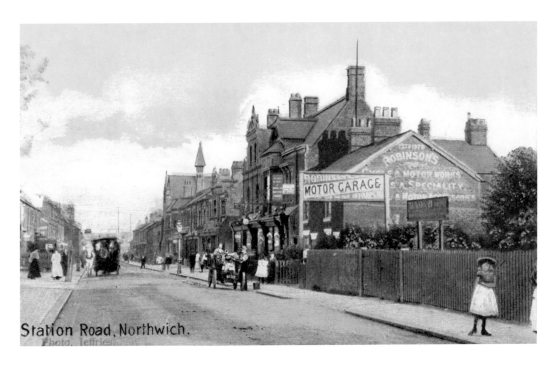

**Isaac Robinson's Car Dealership, pre-First World War and 2015**

In this hand-coloured postcard the same car showroom can be seen from a different angle. Isaac, or one of his salesmen, seems to be handing over what looks like a Renault car. Comparing the two photographs, it does look like this one is older as the showroom seems to have been extended towards the camera. The church shown on the right is the Northwich Wesleyan Methodist chapel that was opened in 1881 and closed in 1977. Dwellings are now on the site.

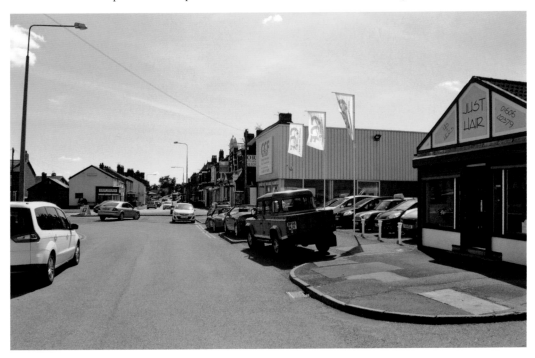

**Nancollis Temperance Hotel, No. 89 Station Road, *c.* 1930s and 2015**

This hotel must have been on its last legs when it was being used by the temperance movement, after the body received a boost by the Liberal government at the start of the First World War. They restricted opening hours, weakened beer and increased tax on alcohol. In 1928, when this hotel was operating, the temperance movement no longer had many followers. It had been running since the early 1800s, when the Maine Liquor Act was passed in the city of Maine, USA, and became popular in the UK for both political and religious reasons – along with a hatred of the evils of the demon drink. In fact the road in which Manchester City football club is situated is Maine Road; in the nineteenth century it was called 'Dog Kennel Lane' but was renamed to commemorate the 'Main Liquor Law' and the influence that the temperance movement had at the time.

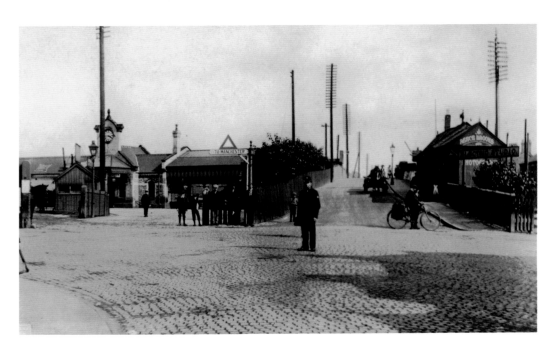

**Northwich Railway Station, *c.* 1920s and 2015**

At the top of Station Road is Northwich railway station. This impressive station was built by the Cheshire Lines Committee in 1897. The line had in fact opened from Knutsford in 1863. Later it was expanded locally with salt branch lines spreading out from the marshalling yards to Marston, Barons Quay and elsewhere serving the many salt mines in the area. The large marshalling yard has now gone to make way for a supermarket and the motive power depot has since been repurposed as housing. Even the station hotel, known as The Lion and Railway, has now become an apartment complex.

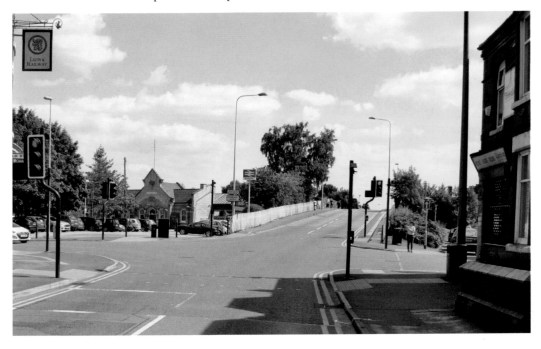

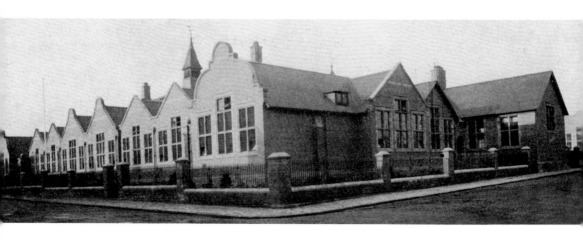

**Victoria Road School, 1906 and 2015**

A then and now look at the popular school situated on Victoria Road. The photograph above shows the school when still quite new, it was built in 1906. Further down the road were the Northwich brine baths, which have now gone to make way for housing. Further still is St Helen's church and its large cemetery.

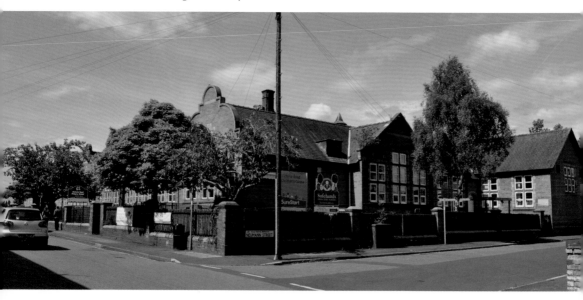

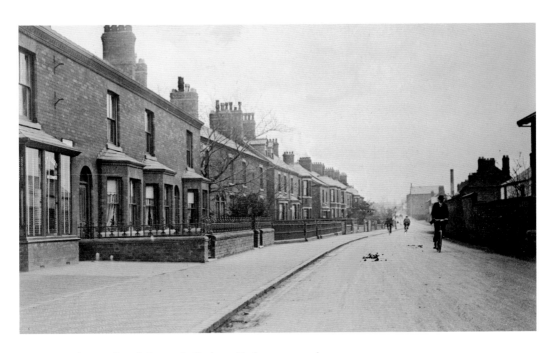

## Manchester Road, Lostock Gralam, Early 1900s and 2015

We now continue out of Northwich on the road that starts near Northwich railway station and continues until it meets the Northwich bypass and thence into Manchester. In the archive photograph the large Lostock ICI works, behind the wall on the right, can be seen with the extensive rail network that straddled the main line to Manchester. The popular Lostock Club, once owned by the ICI and now a private club, can be accessed via the junction on the right (seen in the modern photo). Ahead of this is the bridge over the Trent and Mersey canal, on which is the Wincham Wharf canal business.

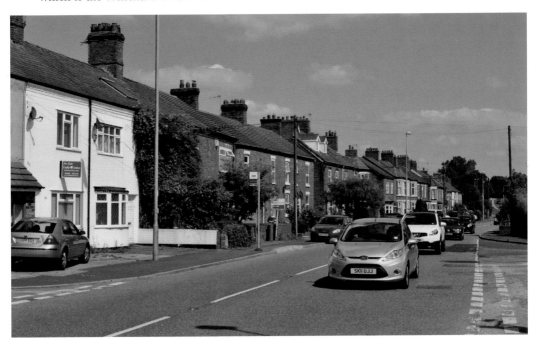

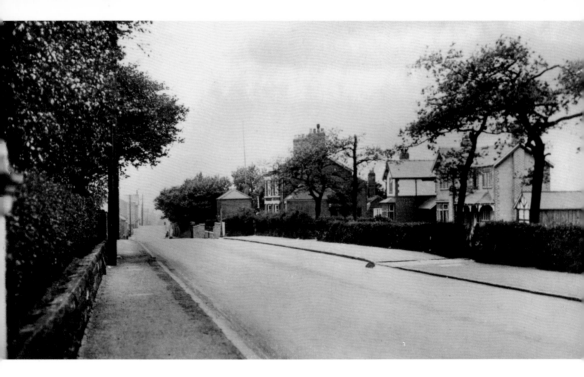

## Manchester Road, Lostock Gralam, undated and 2015

Carrying on along Manchester Road and across the aforementioned bridge, we turn around now and look back from where we have come. Trees have changed the vista here, but the gatepost on the extreme left acts as a point of note in both photographs. I would date the old photo to the mid-1900s, when the roads were much quieter.

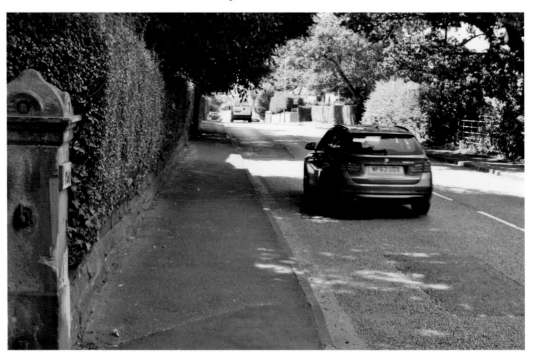

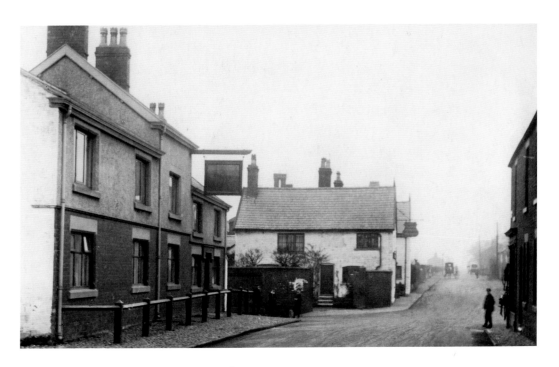

**The Slow & Easy,** *c.* **Late 1800s and 2015**
Continuing a few hundred yards towards Manchester, we come now to an area that was once very busy, as can be seen in the archive photo. The pub on the left is the old Slow and Easy which was later demolished and the new Slow & Easy built further back, as can be seen in the inset. Across the junction on the left which leads eventually to Warrington can be seen the old Black Greyhound.

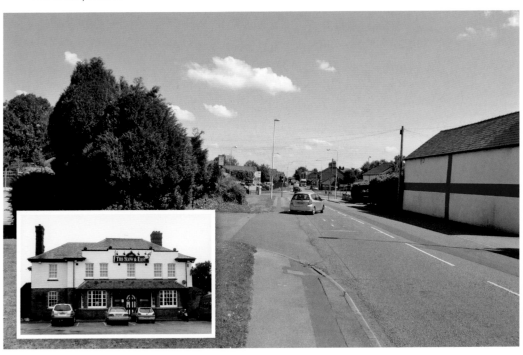

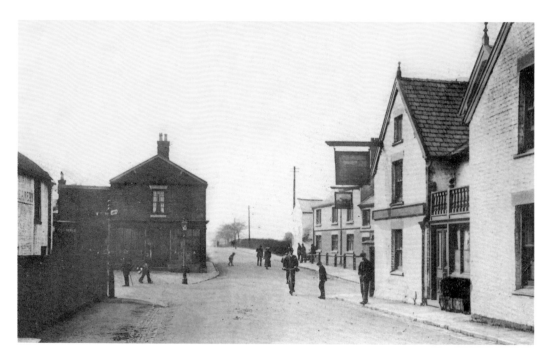

## The Old Black Greyhound, Late 1800s and 2015

Crossing the junction now, this photograph looks back towards Northwich. The Black Greyhound can be seen on the left in the archive photo. Like the old Slow and Easy, this was demolished – later rebuilt on Warrington Road, at Wincham. As can be seen in the inset photo below, this pub has itself closed and has been left to deteriorate. Also note the similarity in the two buildings which are separated by less than a mile and many years in between.

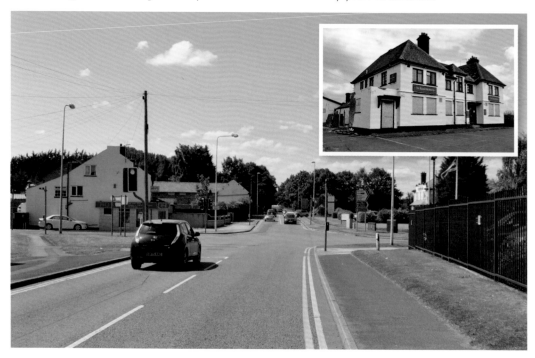

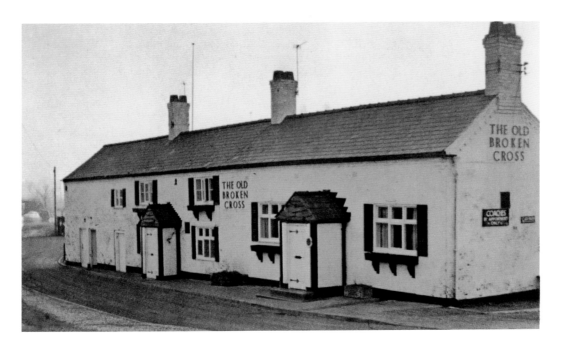

**The Old Broken Cross, undated and 2015**

Back now to Rudheath and a pub that has served the many needs of the canal for 200 years. In the early days of the pub, the canal was the motorway of its day and alongside the pub were stables for the bargees to change horses. The Trent and Mersey canal was built in the late 1700s to connect the River Trent to the River Mersey, and it was to service this canal that the pub, warehouse and stables were built. Goods would be unloaded into the warehouse and conveyed by horse and cart to Northwich where they would continue the journey on the River Weaver as required. The warehouse has now gone and the stables have since been incorporated into the pub.

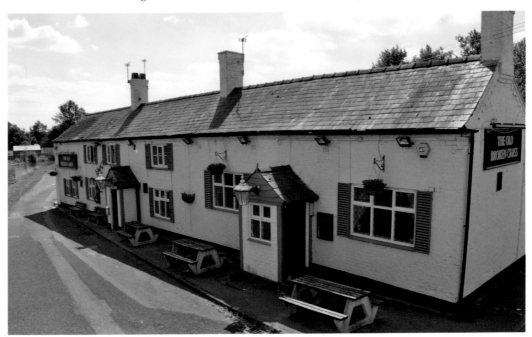

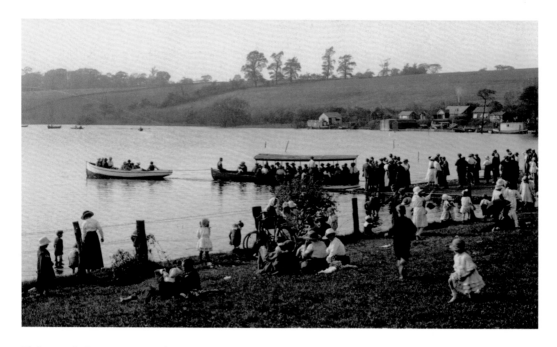

**Pickmere Lake, c. 1920s and 2015**
Once a very popular holiday and day-trip destination, Pickmere Lake is situated just outside Northwich and near to Great Budworth. In 1925 a fairground visited the lake and after this a permanent fair was built providing the usual fairground treats and trips around the lake in cruise boats and rowing boats. Over the next sixty or so years the lake and its attractions became very popular. After sixty years at the helm, the long-term owners, the Cheetham family, retired and the new owners allowed the business to decay. It was soon cleared away and now there is a beautiful mere with pleasant walks and picnic tables.

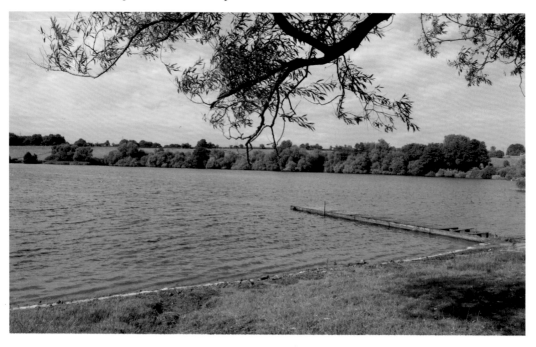

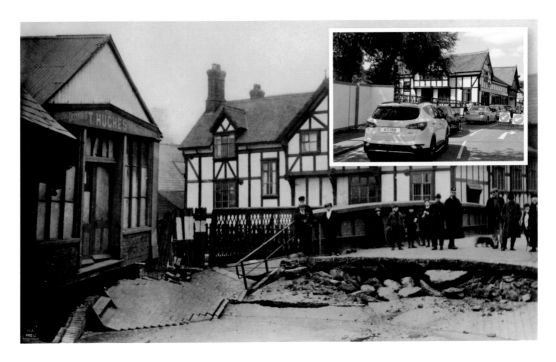

### Dane Bridge, *c.* 1920s and 2015

Above is another good example of the extent of the damage caused by the subsidence in Northwich, in one of the worst locations. In the photograph above (dated to the early 1900s) the bridge has remained relatively straight, though the land and buildings around it have subsided. Dane Bridge crosses the River Dane and has had to be raised many times over the years. One of these operations is seen below in this photograph taken in 1913, as workmen are raising the bridge yet again after subsidence has struck. The inset image shows Dane Bridge today.

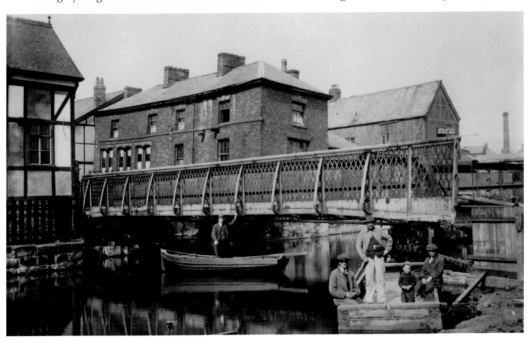

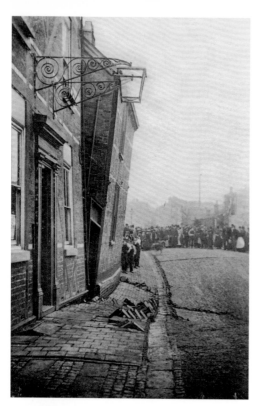

### The Bridge Inn, London Road, c. Late 1800s and 2015

We continue with a view of the devastation in the area near to Dane Bridge. We see The Bridge Inn that once stood here (opened in 1869) and the building next to it. This subsidence will have occurred quite quickly, rendering the inn impossible to save. It was demolished and a new Bridge Inn built in its place. This new building was built with the ability to jack it up in the event of further subsidence. However it was still under threat and it was decided to move it. On the next page we will see just how they did it.

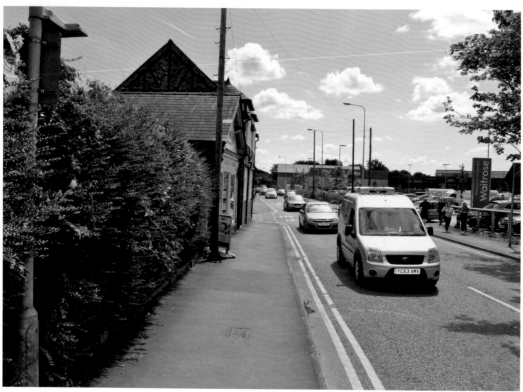

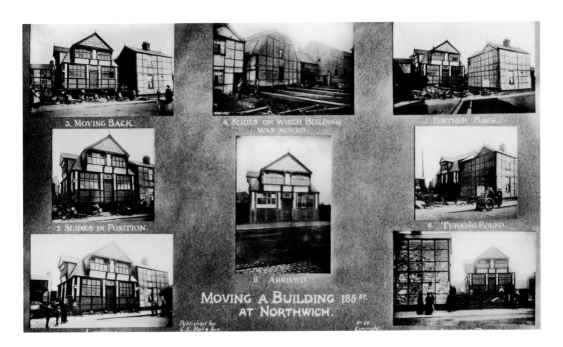

3. MOVING BACK.

4. SLIDES ON WHICH BUILDING WAS MOVED.

5. FURTHER BACK.

2. SLIDES IN POSITION.

6. TURNING ROUND.

8. ARRIVED.

MOVING A BUILDING 185 FT. AT NORTHWICH.

Published by C.E. Hall & Son

## The Story of Bridge House, 1913 and 2015

Here we have a postcard from 1913 showing just how the Bridge Inn (shown in the modern photo) was physically moved with the limited mechanical assistance that was available at the time. The Bridge Inn weighed 55 tons and was moved 185 feet. The building was carried from one side of the building (shown in the archive photo) around the back and into the place once occupied by the old Bridge Inn. The building has had a few uses over the years: starting as a pub, it is now a solicitor's office is interesting to note that the building it was moved around was itself jacked up and repaired.

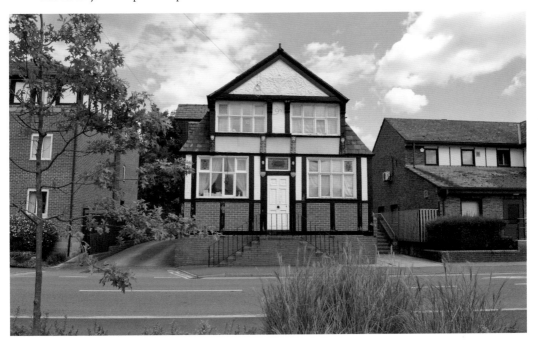

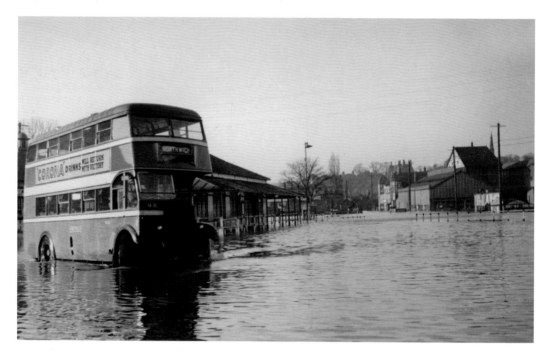

**Northwich Bus Station, 1946 and 2015**

Continuing along London Road to its junction with what was once Brockhurst Street (now Chester Way) and the location of the Northwich Bus Terminus with its North Western Road Car buses (later Crosville).The old photograph shows one of these double-deckers negotiating one of the many floods in the area. The terminus is now a supermarket and the buses have been relegated to a few bus stops in Watling Street.

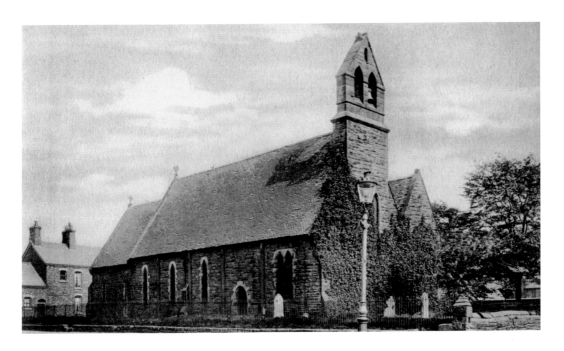

**Dane Bridge Church, Late 1800s and 2015**

We return to the junction now, rejoining London Road to see a church that served the community between 1846 and 1930 – the Dane Bridge St Paul's church of England church. The church had a school affiliated to it that was at the side. At the rear was a Drill Hall that eventually gave its name to the Drill Field – the now redeveloped Northwich Victoria football ground. A graveyard, which probably predates the church, still exists on the junction. To pinpoint the site of the church, note the stone gatepost in the archive photograph which can also be seen in the 2015 photo.

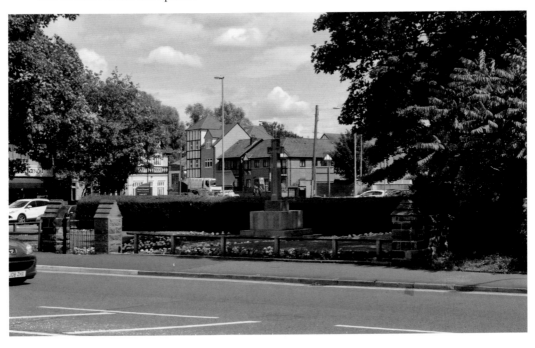

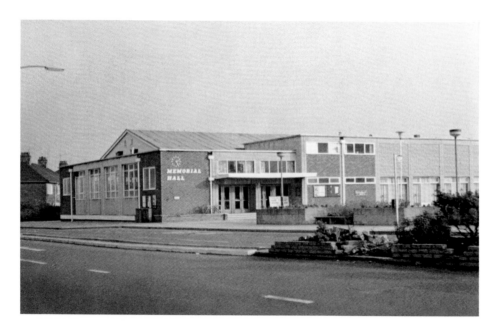

## Memorial Hall, 1960s and 2015

The famous Northwich Memorial Hall, better known as the 'Morgue', which was built in the early 1960s at the dawn of excellent and seminal '60s music. It served as a venue for the likes of The Beatles (who performed there six times), Gene Vincent, Joe Brown, Acker Bilk, The Animals, The Kinks, The Hollies and The Who. I could go on forever listing the many class acts that appeared at this famous venue, which later included Roxy Music. In the same era and area, the black-and-white police station was demolished and a concrete one built over the road. On the site of the old police station a new court was built. The powers that be decided to demolish both the 'Morgue' and the courts in 2015 and build the Memorial Court, which can be seen in the new photo. The exterior design met with much criticism, although the interior is said to be pleasant!

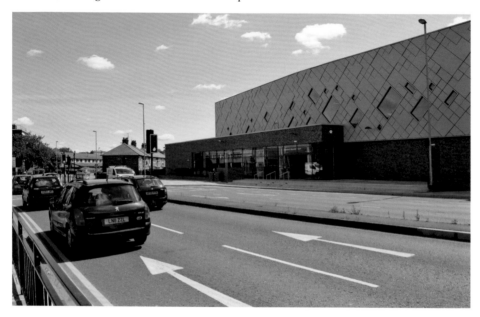

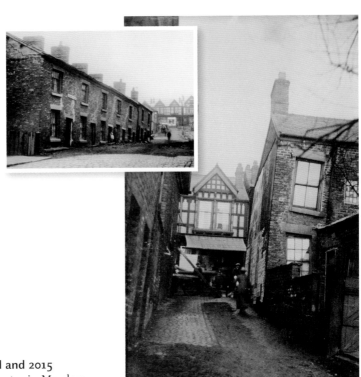

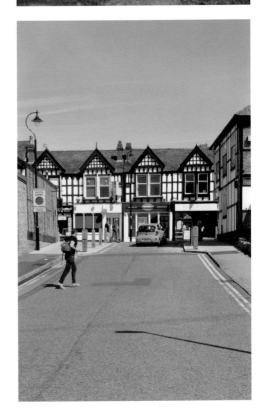

## Meadow Street, undated and 2015

A last look at the town centre in Meadow Street. This was once an area of much poverty, a situation that was not helped when it became an area of much subsidence. This is evidenced by the state of the houses seen in the main archive photograph and the inset (both above) showing more of the road.

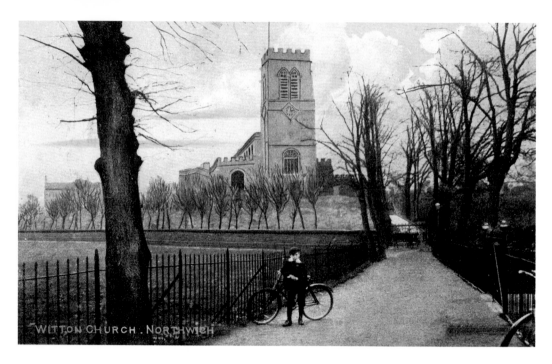

### Church Walk, Late 1800s and 2015

This hand-tinted photograph gives us a good view of the path that once stretched from the River Dane around the Yorkshire Buildings, which once occupied the large car park opposite the present-day police station and to the gates of St Helen's parish church. The boy seen leaning on his bike in the photograph is opposite Church Walk School. During the Second World War, there was an air raid shelter in the vicinity.

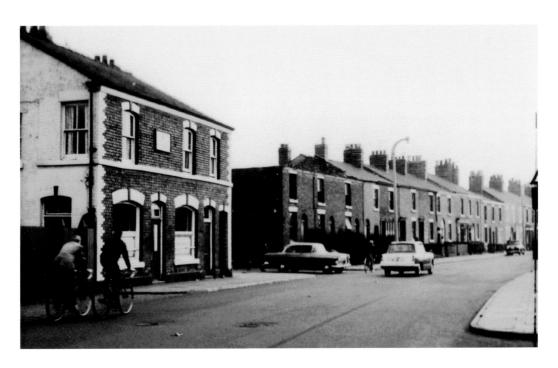

**London Road, The Brass Rods, 1960s and 2015**

Now looking out of the town centre along London Road we see a pub, much altered over the years, on the left. The correct name was the River Weaver Inn but due to the brass rails across the windows it was colloquially known as the Brass Rods. I actually had my first pint in here at, shall we say, 'a young age'! The pub dates from 1867 and the first landlord was Samuel Rogerson who lived there with his family. It closed in the 1970s and was later demolished.

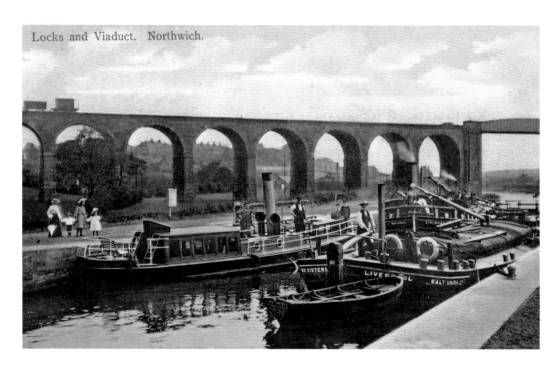

**Hunts Lock,** *c.* **Late 1800s and 2015**

Travelling further along London Road and taking a right turn into Dock Road, we come to the river, and a pleasant walk away from Northwich brings us to this lock on the River Weaver. It is seen here in a hand-tinted postcard and the busy lock contains the *The Pacific*, which was used as an inspection vessel for the Salt Union and listed as a tug (if a posh tug). There are also two Salt Union flats called *Two Sisters* and *National*. In the background are the Northwich arches and the high bridge over the river.

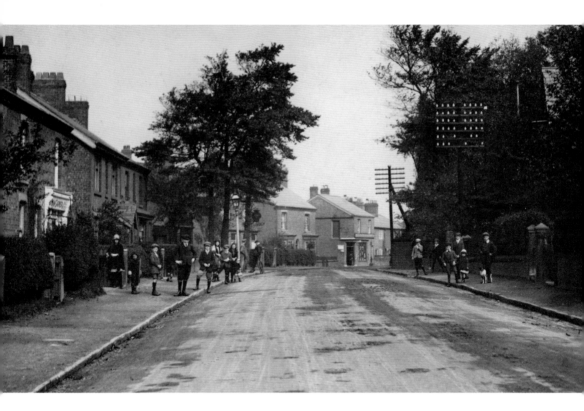

### Leftwich Green, *c.* 1920s

There is no matching modern shot here, but plenty of explanation. Leftwich (or Leftwich Green) was historically a manor and township comprising most of the area between the rivers Weaver and Dane, as well as encompassing the area around Davenham parish church. Leftwich also extended to the north of the River Dane, including the site upon which the new Northwich Memorial Court now stands.

Robert de Winnington was born in 1204. His children assumed the name Leftwich and his son, Richard de Leftwich, was the founder of the family. Throughout the centuries since, the family were the lords of the manor and lived at Leftwich Hall. Little is known about the earliest hall, except that it was demolished and replaced in 1493. Ralph Leftwich later emigrated to what was then the 'new world' and the Leftwich family went from strength to strength in the United States.

In 1616 the hall passed out of the family when Elizabeth Leftwich married William Oldfield – she being the last in direct line of succession. The hall remained in the Oldfield family for around 150 years until it was allowed to fall into decay, eventually being demolished in around 1820. A farm stood on the site until after the Second World War and the site of the hall is now within the boundary of a housing estate that now occupies the site. The only evidence of the former ancestral home is in the name, Old Hall Road.

In 1936 Leftwich civil parish ceased to exist and all of its population was transferred to the civil parish of Davenham; most of the area was subsequently annexed to Northwich. In 1955, as part of a period of post-war construction, the large housing estate at Leftwich Green was erected by Northwich Urban District Council. At the time that the archive photo was taken (at the turn of the twentieth century) this was once a busy road in and out of Northwich, though it has now been bypassed.

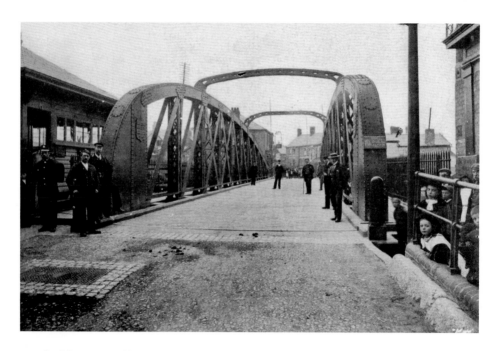

**Northwich Town Bridge, Early 1900s and 2015**

Northwich boasts the first two electrically powered swing bridges in Great Britain. They were built on floating pontoons to counteract the subsidence that the previous bridge had suffered from being lifted over and over again. Eventually it became too low to allow boats to pass. This view of the bridge, both old and new, was taken from the bottom of Winnington Street when it was quite new. The bridge was the second of its type, the first being Hayhurst Bridge in Chester Way, which was built in 1898, and this, the town bridge, in 1899. Both were designed by Col John Saner. As can be seen in the modern photograph, it is now one-way, due to a complete reworking of the road system in Northwich.

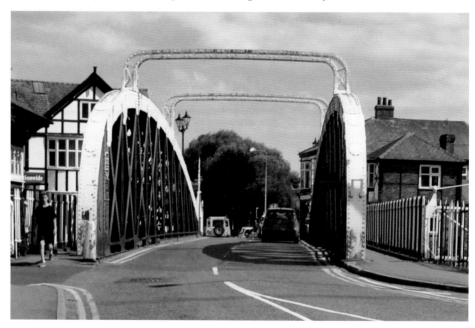

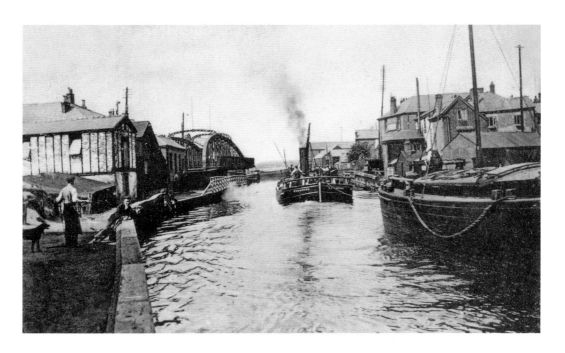

**Northwich Town Bridge, Opened** *c.* **Early 1900s and Closed in 2015**

Another look now at the town bridge, seen here from a different angle as the bridge opens in the early 1900s to allow the salt flat *Cynosure* to pass through on its way, presumably, to Liverpool. The *Cynosure* was built at Winsford by Deakins in 1877 as a sail flat and later converted to steam power. It was sold by the Salt Union in 1926. In 1928 it was rebuilt and renamed *Lothersdale*. In 1938 it was converted to a motor vessel. Over the years the cross bar on the bridge was heightened to take high modern wagons. The building being erected in the background in the new photo is the Barons Quay development.

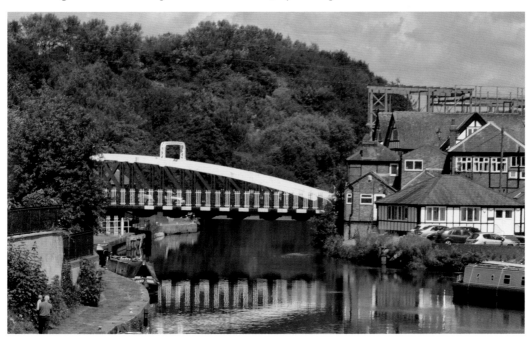

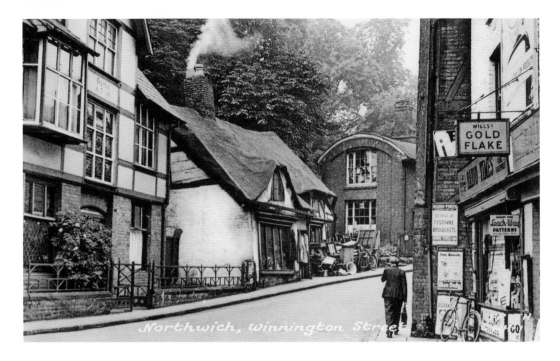

**Lower Winnington Street, c. Early 1900s and 2015**

Here we turn from the bridge and look up Winnington Hill. One of the most famous buildings in Northwich was Joe Allman's junk shop, seen here with the smoke drifting lazily from the chimney. The building was built as two small cottages in the 1600s and went on to be transformed into an iconic and well-loved Northwich shop. It still had a soil floor until well into the second half of the twentieth century, when Joe still traded at the age of ninety.

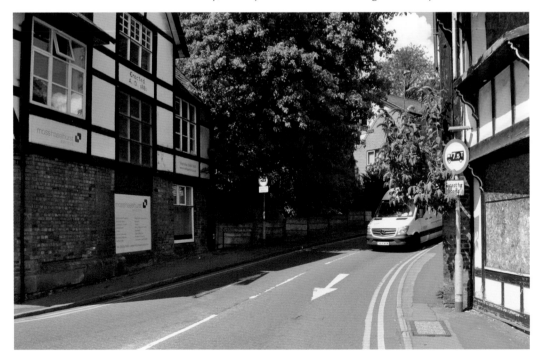

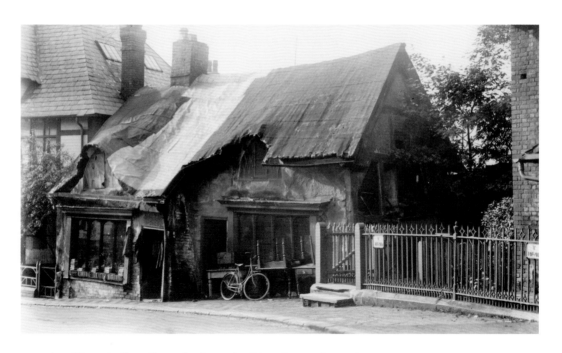

**Joe Allman's Shop from the Opposite Direction, 1960s and 2015**

Passing the shop now, we look back with a nice high definition archive photograph of Joe's shop. The once thatched roof, later covered in roofing felt, is showing advanced signs of wear, signalling that the shop's days are numbered. Despite a public outcry when it was announced that it would be demolished, the council went on and did the evil deed. They also demolished the barrel-roofed building next to it. Rumour has it that demolition companies fought for the rights to demolish this ancient building thinking that they would come across riches. They were however very disappointed.

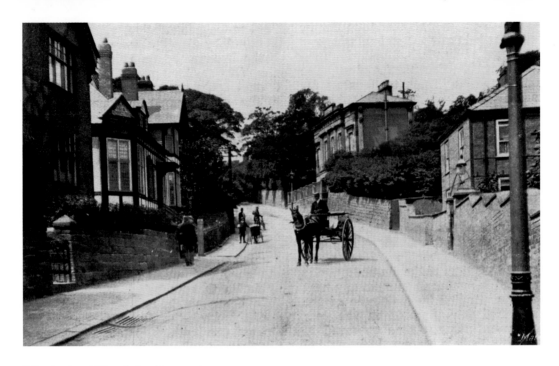

**Winnington Hill,** *c.* **Late 1800s and 2015**

A final look up Winnington Hill shows that most of the buildings which were higher up are still there, less the large house on the right that would have been in the vicinity of Oldham's Hill. This road continues on to the Winnington Lift Bridge, famous for the Battle of Winnington Bridge in the English Civil War. The road then continues to Anderton and the famous Anderton Lift that takes boats from the canal to the River Weaver; the other way leads to Barnton and onward to Bartington and Runcorn.

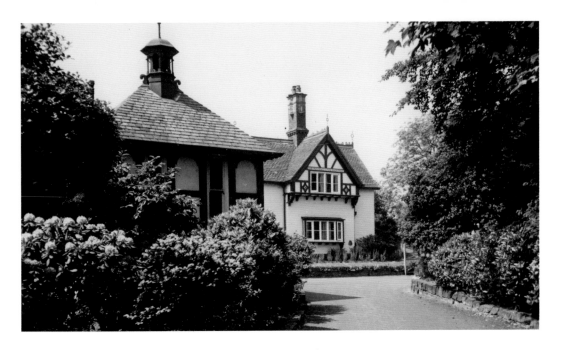

### Verdin Park Entrance, undated and 2015

Walking up Winnington Hill we find the opening to what was once the gate to the Northwich infirmary. The white house that can be seen in the archive photograph was used by a member of staff and bore the words 'God's providence is mine inheritance'. The lodge has lost its roof ornament over the years, but was at one time the carriage entrance lodge to Verdin Park. The buildings in both photographs are the same – it was just difficult to get the same angle. Inside the gate is one of the hospital buildings bearing the plaque shown in the inset photograph. This was installed to celebrate the opening of the extension by King George VI in 1939.

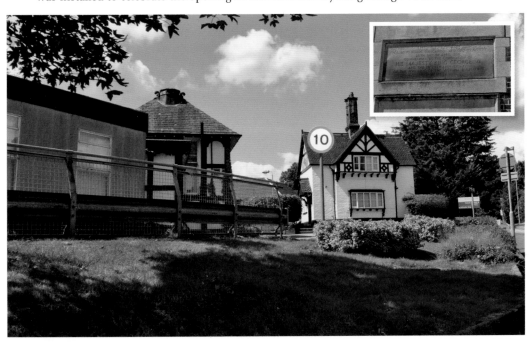

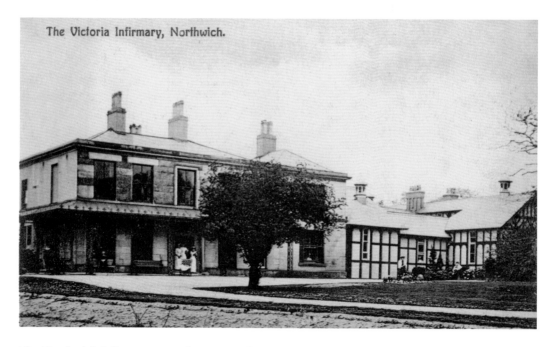

The Victoria Infirmary, Northwich.

### The Northwich Infirmary, c. Early 1900s and 2015

Here we see the original Northwich Victoria building that was presented to the town in 1886 by the town's member of parliament, Robert Verdin. He was a philanthropist and he gave the house, which is now the Victoria Infirmary, to the town. Now used as a hospital, it is still treating the people of Mid Cheshire and has been vastly extended over the years. Robert Verdin inherited the family salt business from his father, also called Robert, and by 1880 the company Joseph Verdin & Sons was the largest salt manufacturer in Britain producing 353,000 tons of salt annually. The company had salt works and mines in various locations including Marston, Over, Wharton, Middlewich and Witton.

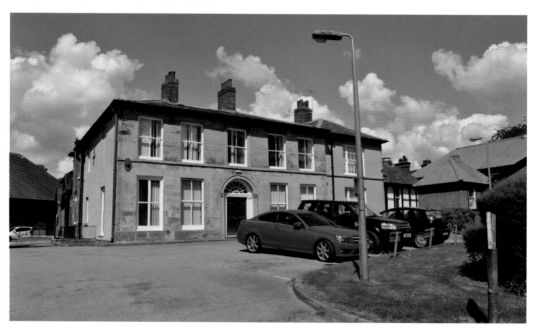

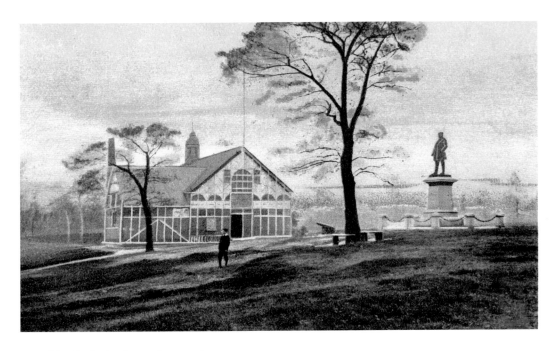

**Verdin Baths, Late 1800s and 2015**

Here we have a hand-tinted postcard of Verdin Park showing the statue and the swimming baths. Robert Verdin was a Northwich businessman and politician. He gave Verdin Park and then the Verdin baths that were built on it to the town and it was opened in October 1887 by Lord Stanley of Preston. Robert Verdin never married and lived with his brother Joseph and Sister Mary at The Brockhurst, a Regency house that is still there in Leftwich. A statue in his memory is still in Verdin Park. He died at The Brockhurst in 1887. The modern photo shows the still very popular Verdin Park with the statue today. The baths suffered from subsidence and were demolished.

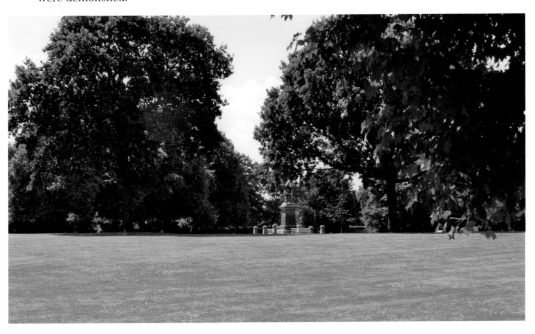

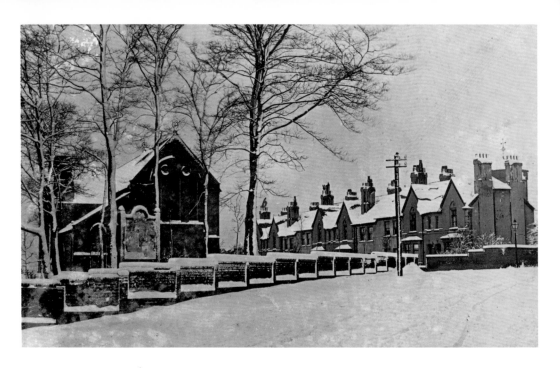

**Dyar Terrace, 1905 and 2015**

Still in Winnington, this photograph is taken on the outskirts of the chemical works at Brunner Mond and looks at Dyar Terrace in the snow. The houses seen here were of a more substantial build as they were for the managers of Brunner Mond. Around 200 houses were built by Brunner Mond for their employees after the company started trading in 1873. The church in the old photo is St Luke's, which we will look at in more detail in the next caption.

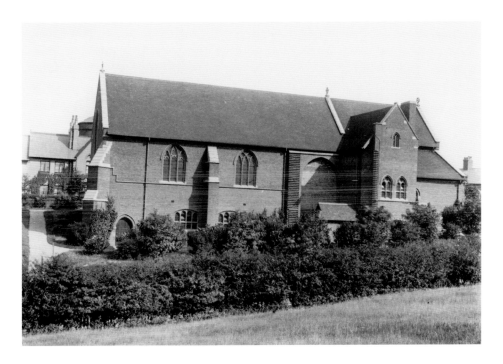

## Winnington Church, 2015 and 1980s

A church was opened near here on 20 December 1884 after an increase in the population of Winnington due to the arrival of Brunner Mond Ltd. It was built of corrugated iron and known locally as the 'tin church'. The present church of St Luke was built by Brunner Mond. The church is quite unique in that the hall is below the church, taking advantage of the sloping ground. The church is now closed and is currently being demolished.

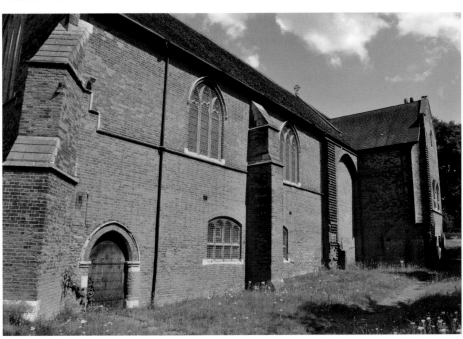

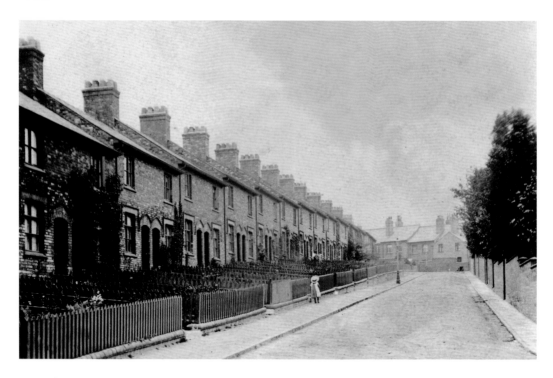

### Hemming Street, *c.* Late 1800s and 2015

We continue into the Brunner Mond-built estate and to a row of workers' houses in Hemming Street. These are good sturdy houses, built when labour was relatively cheap and building quality to a good standard. At the time of the first photograph, the houses were quite new. Over the years flora and fauna have taken over this quiet backwater of Winnington.

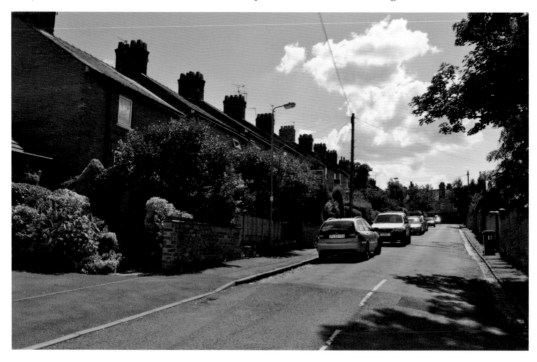

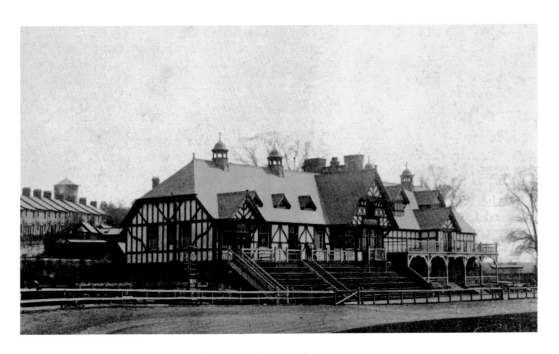

**Winnington Recreational Club,** *c.* **Late 1890s and 2015**

Looking now at another Brunner Mond building, this photograph shows the aforementioned Hemming Street in the background. Better known as 'Winnington Rec', this was built by the company in 1890 and is still open and doing well. As can be seen by comparing the two photographs, over the years there have been many changes to the architecture. The sports ground was provided with a grant of £500 from Brunner Mond, who also provided the land. There was a serious fire in 1944 – ironically enough, this happened after the Fireman's Ball. This was rebuilt and the club continued to provide a social environment for the employees and later the members.

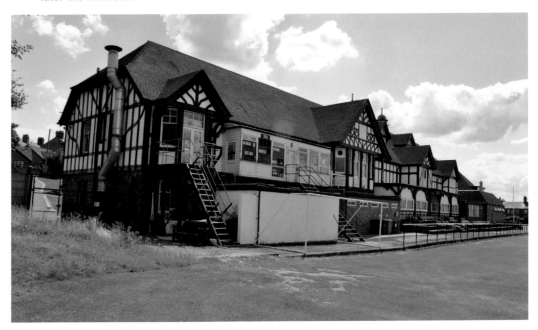

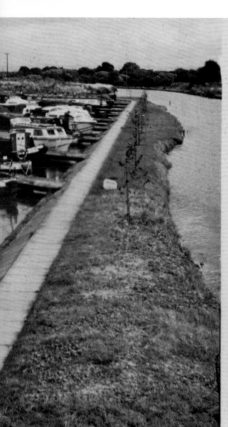

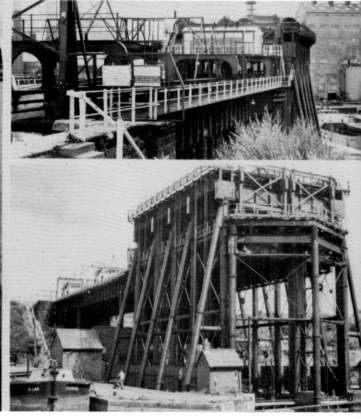

### The Anderton Lift, undated

This photograph looks at what was once one of the wonders of the canal network, the Anderton Lift. We know that salt has been extracted from beneath Cheshire since Roman times and by the end of the seventeenth century the industry had developed.

In 1734 the River Weaver Navigation was made navigable through Northwich and on to Frodsham and the River Mersey. In 1777 the Trent and Mersey canal was opened allowing goods to be carried from the coal and pottery industries around Stoke on Trent. The owners of the canal company and the Weaver trustees decided to work together and in 1793 a basin was excavated on the north bank of the river at Anderton. The river then ran close to the escarpment of the canal that was 50 feet above it. Anderton became a major hub in the transport of salt by canal when facilities were built to trans-ship goods between the two waterways. This later included four salt shutes from canal to river. The pub at the top, the Stanley Arms, became known as 'The Tip' as a result of this and does to this day.

The facilities were regularly updated, by 1870 Anderton was a major transportation hub. A boat lift was planned by the trustees to carry canal boats from canal to river and their chief engineer, Edward Leader Williams, was tasked with the job of planning the lift. Originally it was a pair of water-filled caissons that counterbalanced each other when travelling up and down. The result can be seen in the above photograph; later electricity was used to power the lift.

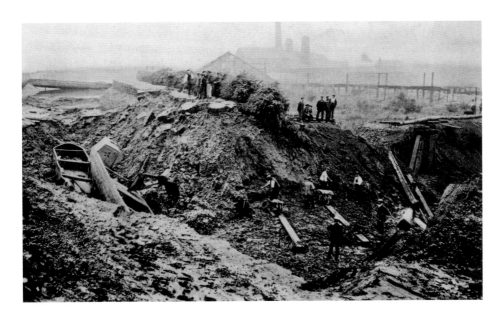

## Canal Breach, 1907, and an undated Canal Breach

The earliest canals date back to the Persians in around 515 BC, and earlier still to the Chinese in the third century, when they were used for both irrigation and transport. The canal network in Britain followed on from horse-drawn vehicles, the earliest canal being the Bridgewater canal, which was built between 1759 and 1762 by James Brindley. 'Canal mania' then started with Brindley in the forefront as canals criss-crossed the country. Mid Cheshire was an important part of this with Northwich at its centre and Middlewich an important hub. Occasionally canals burst; this was due to landslip or extreme weather but in the case of Northwich, it was more likely to be subsidence. Here we see two photographs showing the result of a breach in Northwich at the turn of the last century. Imagine the work involved in repairing them with no mechanical assistance and just manpower and barrows to reconstruct this important waterway.

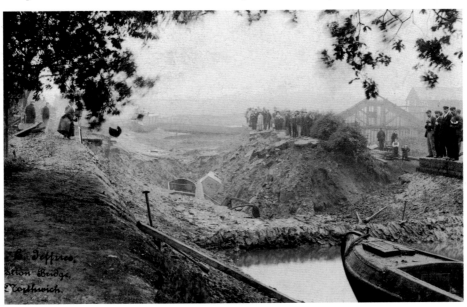

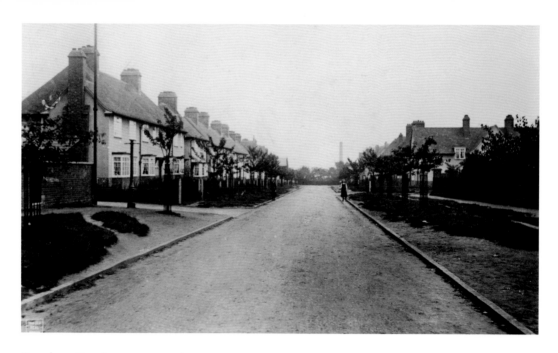

**Broadway Barnton, *c.* 1920 and 2015**
We now reach the village of Barnton. Like others surrounding the massive chemical works of Brunner Mond ICI, this village found itself growing rapidly to accommodate the many new workers drawn to the works from surrounding cities, especially after the Second World War. Further back in its history the village became known as 'Jam Town', and still is by the older generation. This comes from the late 1800s when many of the residents ate jam sandwiches because they could afford to own their own house and not have to pay rent; some could even afford to buy the houses of their neighbours!

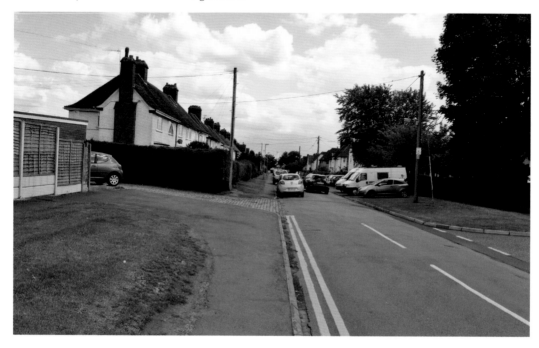

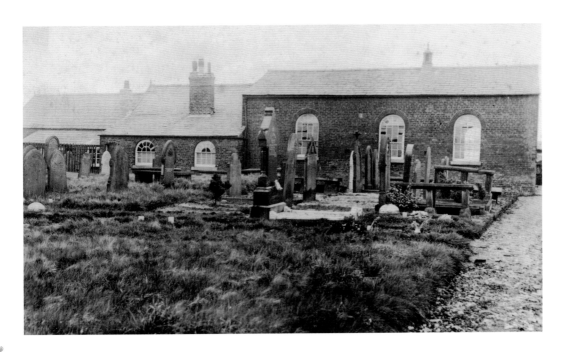

**Baptist Chapel, Little Leigh,** *c.* **Early 1900s and 2015**

From Barnton we travel to another pleasant village, this one called Little Leigh. The archive photograph above shows the small chapel there. The graveyard has been much extended and contains the grave of Revd Thomas Fownes Smith; there is also a plaque dedicated to him in the chapel. 'The Farmer's Boy' is a popular folk song in Britain that has been used as the marching song for several regiments around the world, the composer being his brother-in-law Charles Whitehead. It is believed to have originally been written in Little Leigh and based on the life of the Reverend Smith, who preached here for thirty years.

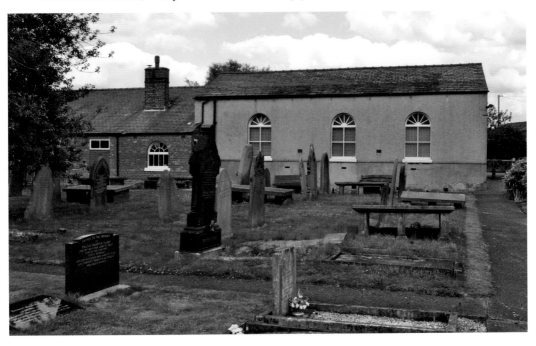

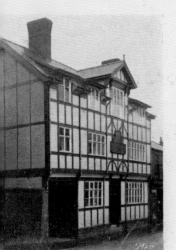

**The Sportsman, Northwich, Early 1900s
and 2015**

We make our way back into Northwich now to take another route out. If you turned right on to Castle Street at the bottom of Winnington Hill during the turn of the twentieth century you would find a large and impressive hotel backing onto the river. This hotel was the Sportsman's and the landlord, at the time when the old advert was being used, was Jas A. Gorst who was the incumbent from 1909 to 1949. The hotel was first opened in 1776 as The New Eagle & Child and in 1820 it became the Sportsman. Always busy and always popular, the hotel was still in use until 1976 with the landlord who had taken over from Mr Gorst in 1949. For some time after it closed the building was left to decay, suffering a fire and finally being demolished.

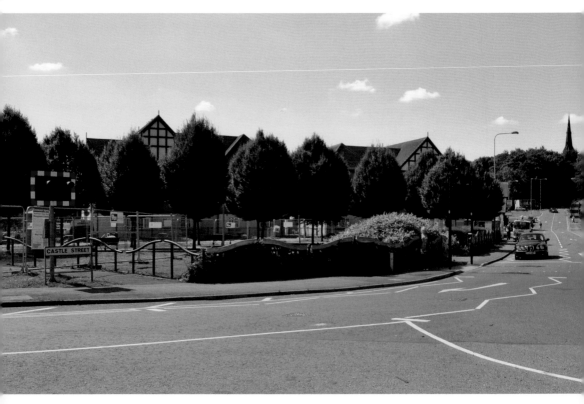

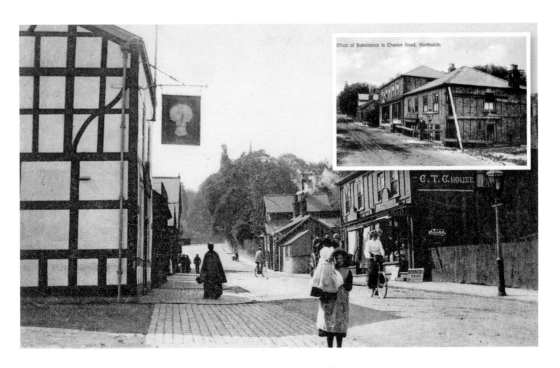

## Castle Hill, Late 1800s and 2015, with Inset dated Early 1900s

This hand-tinted postcard looks up Castle Hill, showing the Wheatsheaf pub and, across the road, the restaurant owned by Mrs Mary Platt, with dining rooms that hosted wedding breakfasts, picnic parties and balls etc.; cyclists were also catered for. Game and other meat pies could also be made to order. The inset photograph shows the same building sinking into the ground due to subsidence several years later.

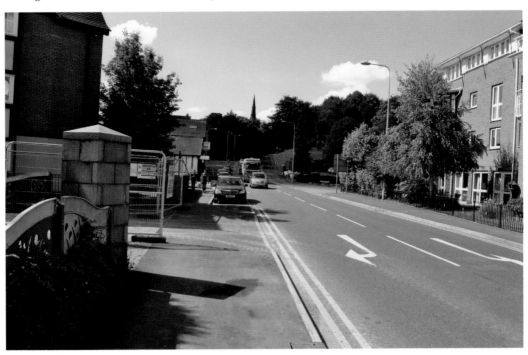

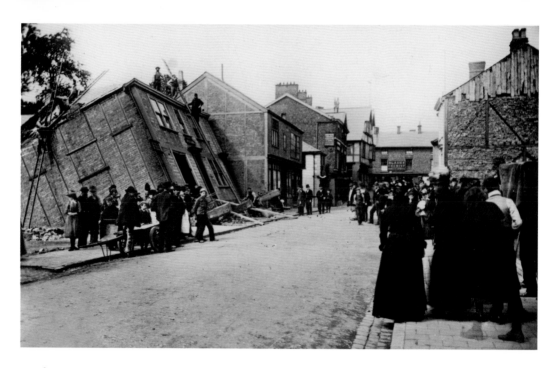

### Castle Street, Turn of the Twentieth Century and 2015

Turning around now, this photograph is taken looking towards the town bridge during the worst days of subsidence. Ladies in their Victorian clothing can be seen watching as the workmen start to dismantle the building that has simply slid back into the ground. The Mosshaselhurst Solicitors building can be seen in the far distance and is still there to this day. However, the building next door has gone to make way for the garage that was built in 1920.

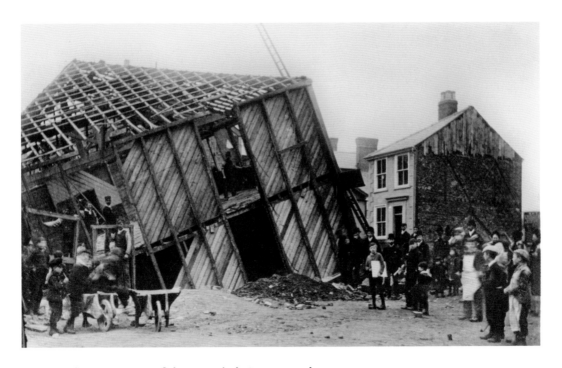

## Castle Street, Turn of the Twentieth Century and 2015

Here we see the same building as in the last pair, but this time partially dismantled. The photograph shows the way the building was built out of wood. This was done in the expectation that it would eventually subside, the thinking being that, if it did, the people inside would not be harmed to the same extent as they would in a brick building. Most of the buildings in this area were too damaged to jack up. It was a long and traumatic time for the people of Northwich.

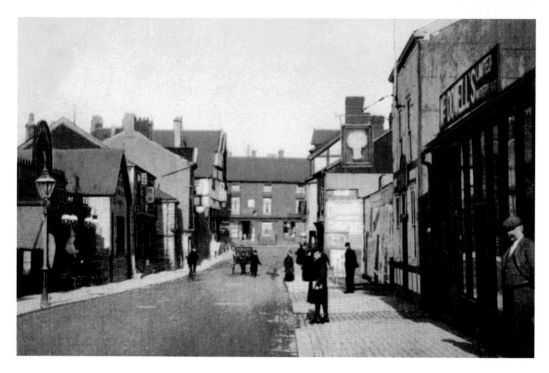

**The Wheatsheaf, Intact, 1800s and 2015**
Here we look back towards the Bullring in the days before subsidence changed the look of this area completely. The Wheatsheaf pub is still intact in archive photograph and the red-brick building in the far distance is still standing also. This building was later demolished and the black-and-white one was built as late as the '70s. This building is now derelict itself.

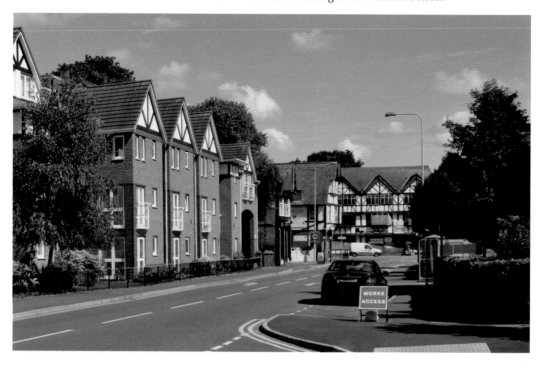

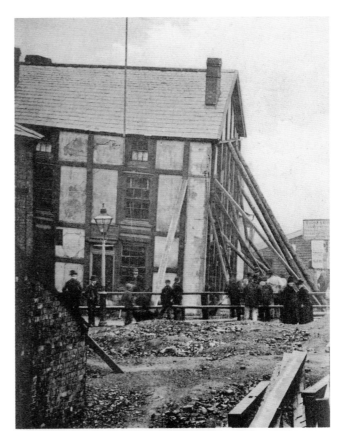

## The Wheatsheaf Collapse, Early 1900s and 2015

Having seen the Wheatsheaf in better days, we now see it after it collapsed and had to be completely demolished. In the archive photograph props have been attached to stop it falling into the road. After this building was removed another pub, with the same name and just one storey, was built on the site. The pub shown was opened in 1775.

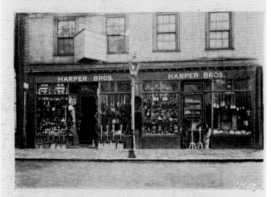
**Harper Bros., Castle Street, Early 1900s and 2015**

The photograph above bears an example of just how busy the lower end of Castle Street was. This advert was for the Harper Bros' furnishing and ironmongers, which was at Nos 9 and 11 Castle Street. The modern photograph shows the same area in the present day and the new housing that has been built.

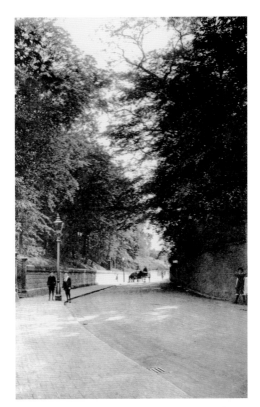

**Castle Hill, Turn of the Twentieth Century and 2015**

This steep hill going out of Northwich town centre via the ancient Castle Hill. Castle Hill is far busier today and the road is now one way from the traffic lights to the Bullring. It is fair to say that this extensive one-way system has not met with total praise from the people of Northwich. The Castle area once had a castle or Roman fort in the vicinity that dated from AD 70 but by the 1600s there was no sign of it.

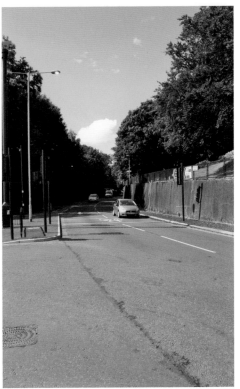

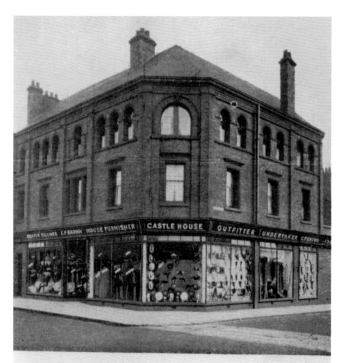

"CASTLE HOUSE,"
NORTHWICH.

G. P. BROWN,
*Proprietor.*

**Castle House, Turn of the Twentieth Century and 2015**
This large and impressive shop sits on Chester Road, which leads to Castle Street. The old advert, dated around the turn of the twentieth century, details the proprietor as being George Brown. The 1892 directory lists him as being a draper, house furnisher, dress-maker, milliner and undertaker. This part of Northwich was once a busy annex to the town centre and boasted a road filled with shops. It is now a lot quieter during the day, though still has some good shops and many restaurants that open in the evening. Castle House is now a share property housing a highly regarded bakery and hairdressers.

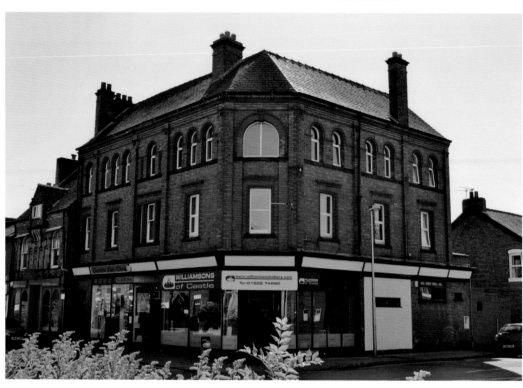

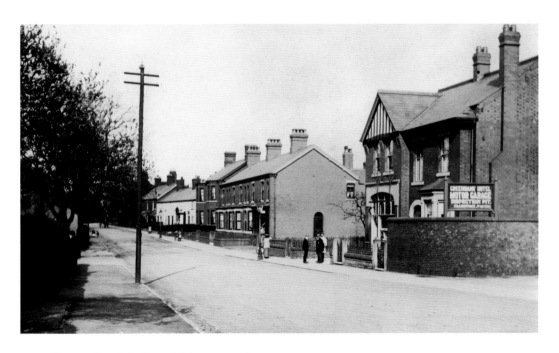

## Chester Road, Early to Mid-1900s and 2015

In this photograph we carry on along Chester Road and under the old ICI railway bridge known as the 'Iron Bridge' until we arrive at the Greenbank Hotel. Before actually reaching the hotel, we look back towards Northwich and see that trees and foliage have, since the first photograph was taken, intruded most pleasantly into the vista. The building in the foreground has not changed much other than losing the tops of its chimneys. Note the garage sign: on the next set of photographs this sign has Greenbank Hotel painted on it. This probably indicated that this archive photograph is not as old as the next one.

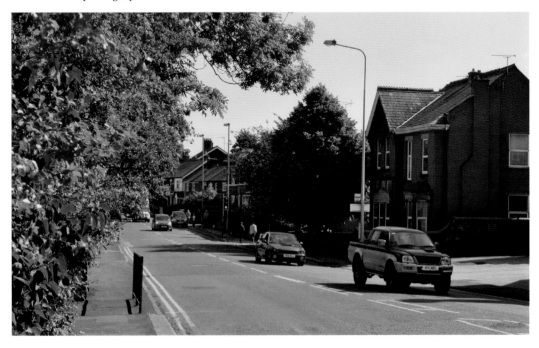

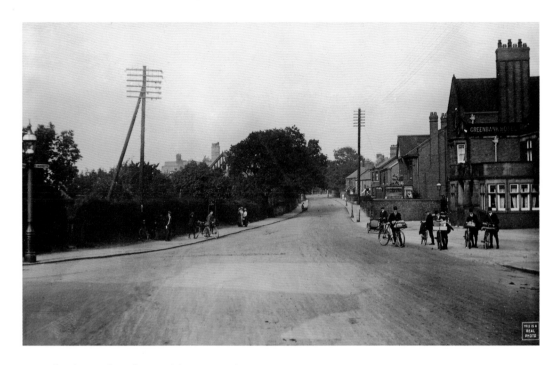

## Greenbank Hotel, Early to Mid-1900s and 2015

We now reach the large Greenbank Hotel on Chester Road. This large and imposing hotel was built in 1894 and provided accommodation for users of the adjoining Greenbank station. Permission to build it was only granted on condition that other pubs nearby were closed. The name of the station was Hartford & Greenbank but this was later changed to simply Greenbank. In the old photograph it looks like the local postmen have stopped for a meeting.

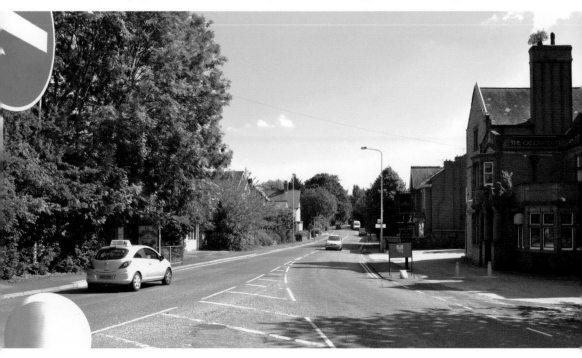

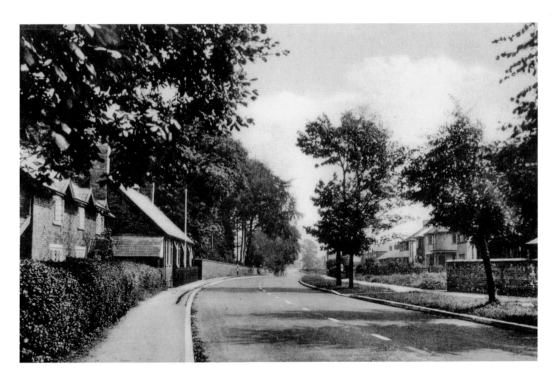

### School Lane, Hartford, undated and 2015

Carrying on away from Northwich and into Hartford, we come now to School Lane, named for the school that can be seen on the left after the house. This was the main schoolbuilding in Hartford, built in 1833. The building now houses the Hartford Old School House Day Nursery. A more modern primary school is situated in Riddings Lane.

## Chester Road, Hartford, 1964 and 2015

The archive photograph shows Hartford village in the 1960s and looks in particular at a nice, quiet road. Even in the modern photograph the road seems quite peaceful, but this is not the usual view. Rather controversial house building is taking place behind the camera. It was in this location in 1944 that an RAF Albemarle bomber crashed; one of the crewmen, Sgt Gerry Crowe, lived in one of the houses. The plane flew over twice, skimming the rooftops and clipping a chimney before continuing over Chester Road where it hit the tops of the trees and crashed into the wall opposite the church and shops. The Canadian pilot and Gerry Crowe both died, though the gunner was rescued by a passing US Airman. One of the engines flew off in the crash and almost hit a baby's pram. One reason given for the incident was that a plane from Derbyshire buzzed the home of one of the crew in the middle of Cheshire and crashed due to engine trouble. Despite this explanation, the facts seem to point to a madcap escapade going wrong. There is a plaque on the wall at the scene as can be seen here in the inset.

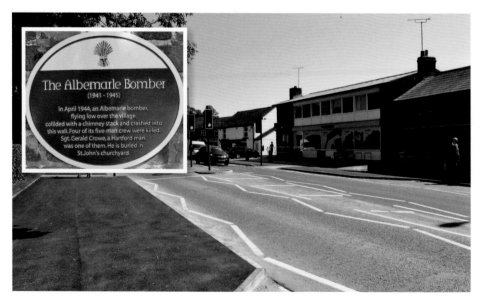

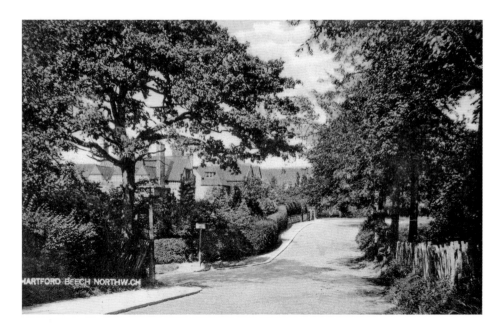

## Beach Road, Hartford, Mid-1900s and 2015

We are now on the road between Weaverham and Northwich and another part of Hartford that was once known as Hartford Beach, and still is by some. Beach Road is an unusual road name for land-locked Mid Cheshire. One of the road signs actually says Beech Road – as does the caption on the photograph. In 1865 Thomas Horatio Marshall Esq. lived at house nearby called The Beach, which was described in Whites directory of 1860 as 'a handsome residence' – it still exists but is now two semi-detached properties. The Marshall family were members of Cheshire's landed gentry and also resided in Hartford Manor. They were local benefactors and proprietors of salt mines. The road on the left is Burrows Hill and leads down to Winnington Avenue and Wallerscote Road.

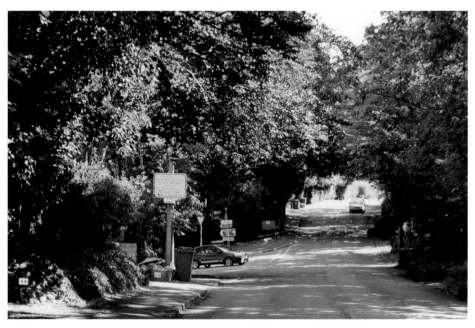

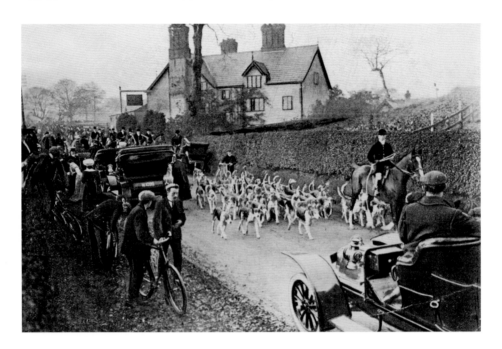

### The Blue Cap, Early 1900s and 2015

An unusual photograph now showing the hunt meeting on the road that is now the Speedwell Hill part of the dual carriageway or Northwich bypass. This ancient road from Chester to Manchester once carried the mail coaches that travelled between the two cities and onwards. Hotels were used as staging posts for this traffic and an important one was the Sandiway Head Inn. This famous old inn, which stood on the foundations of an even earlier one, was later to have its name changed to The Blue Cap. This was named after a dog with this name who won a race and whose statue is in the porch of the pub.

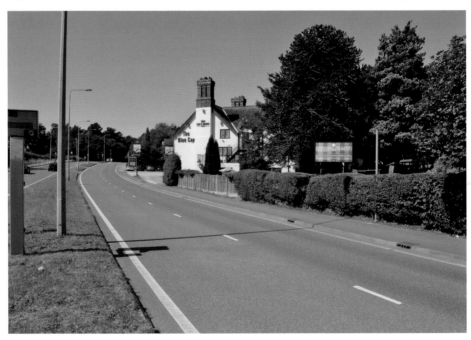

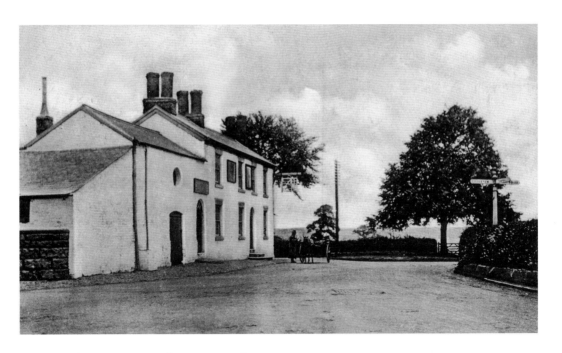

## Hanging Gate, Weaverham, 1905 and 2015

Weaverham is another village that comes under the jurisdiction of Northwich. 'This gate hangs well and hinders none refresh and pay and travel on': these are the words that travellers over the years have looked up and read as they pass the farm gate. The gate has for many years hung from the wall of the pub on what was the main road from Whitchurch to Warrington. It is believed that when the nearby toll gate closed in the 1800s the gate was hung on the wall and the pub's name changed to The Weaverham Gate Inn during 1827. It was later called The Barrymore Arms and then simply The Gate. It was owned by Lord Barrymore until it was purchased by Greenall's in 1928. The pub is now an Italian restaurant called the Casa Matta Ristorante and Pizzeria.

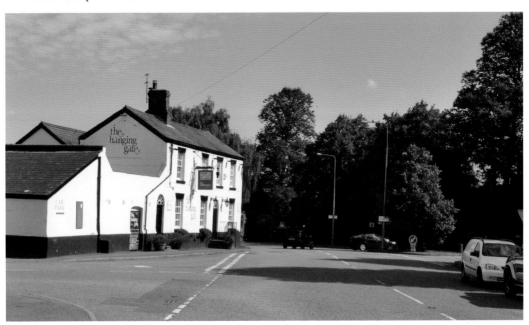

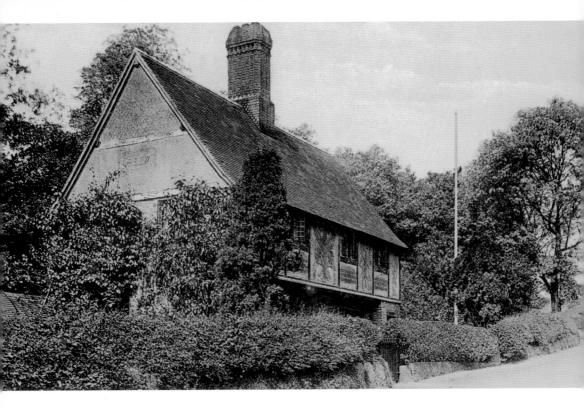

## Estate Cottages, Great Budworth, undated and Self-Standing

This building is a lovely house on the crossroads leading up to the village of Great Budworth. I have just used the one archive photograph as the present-day house is surrounded with verdant greenery and would not make a good photo.

It was built as a pair of estate cottages in 1868 by the famous Cheshire architect John Douglas, who was responsible for the rebuilding of many buildings in Chester in the attractive mock Tudor black-and-white. They were built for Rowland and Piers Egerton-Warburton and called Dene Cottages and are now listed buildings. At the front elevation there are words set on plaster panels and they read, 'take they calling thankfullie: love thy neighbour neighbourlie: shun the road to beggarie'. The houses were built for the staff in the nearby Dene House in Warrington Road and there are other panels showing floral motifs and. Piers Egerton-Warburton was Lord of the Manor.

Over the road is the running pump; the shelter is also a listed building known as the Dene Wellhouse. Inside it is a plaque inscribed with a verse by Rowland Egerton-Warburton from Arley Hall. He commissioned John Douglas to design and alter Great Budworth to make, it in his words, 'attractive to Victorian eyes'. He also commissioned Douglas to construct non-religious buildings in the villages on his estates. As for Great Budworth, it was certainly a success as the village is still probably the prettiest in Cheshire. Rowland Egerton-Warburton is buried in the family crypt in Great Budworth church and John Douglas has a plaque in his honour on a wall in St Werburgh Street Chester and is buried in the city.

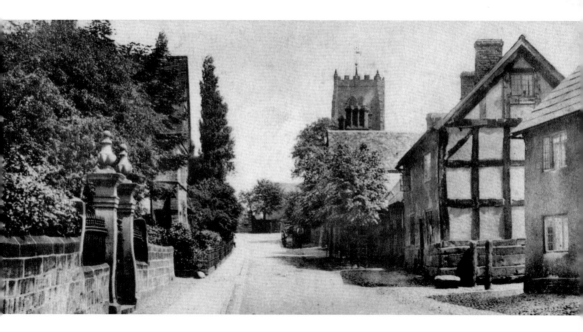

### Great Budworth, 1905 and 2015

We now ascend the hill into a place often described as 'the most picturesque village in Cheshire', the village of Great Budworth. It has been used as the setting for many period films and television programmes over the years, the most recent being *The Zoo*: a series about Chester Zoo on the BBC. The old photograph shows the village devoid of any traffic other than a man and his barrow; at the time only horse-drawn traffic would intrude upon the scene, although the dawn of the internal combustion engine had started to make an appearance. The modern photo shows the village unusually quiet, but the next caption will show that this is not always the case with many cars parked in the road. Most of these will be customers of the George and Dragon pub, the only one in the village.

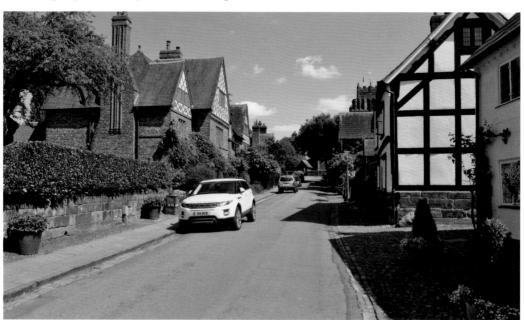

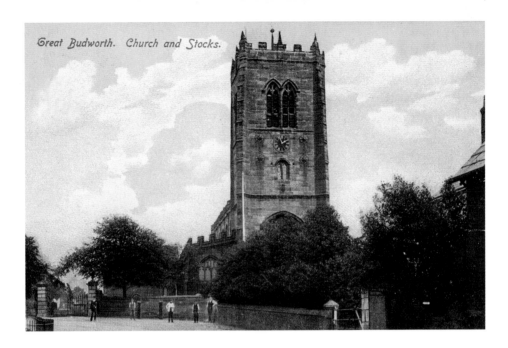

*Great Budworth. Church and Stocks.*

### Great Budworth Church, Rarly 1900s and 2015

Continuing up the hill in the village, we are met with an attractive view of the church of St Mary and All Saints. The old photograph is hand tinted and shows some of the locals around the village stocks. The church itself is the centrepiece of the village and is in Gothic style, dating from the fourteenth century – the church register goes back as far as 1559. The building was thoroughly restored in 1870 and outside the church there still stand the village stocks in which minor offenders were held to face the wrath of the villagers with their rotten fruit and abuse. Many an unruly youth spent time in them in the past – far be it from me to suggest that the practice should be reintroduced!

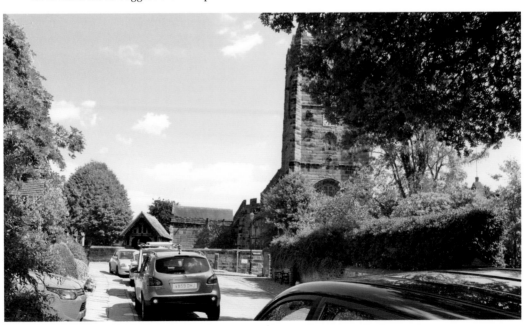

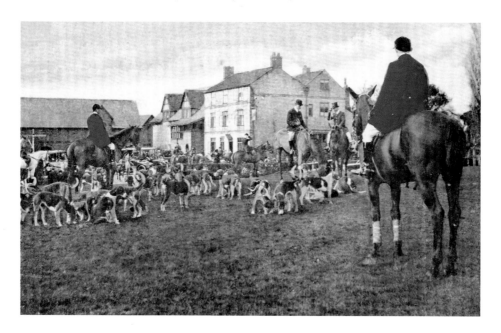

### The Cock, Budworth, undated and 2015

Back now to the Warrington Road just up from the village and we find a large and imposing pub with cobbles around it. The pub known as The Cock was formally owned by the Warburton's of Warburton and Arley Hall until Greenall's purchased it from them in 1932. It has been in existence since 1770 and the hand-tinted archive photo of it dates roughly from the turn of the twentieth century. It was virtually impossible to replicate this scene exactly on account of the very busy road between the huntsmen and the pub. They were on the other side of the road in what is now a corn field. The pub itself is now owned by the Joseph Holt brewery and is even more attractive inside than it is out, although that itself cannot be faulted. It has just gone through a major refurbishment, which was tastefully done and in keeping with the building's antiquity.

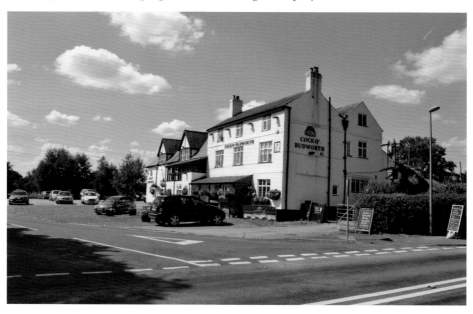

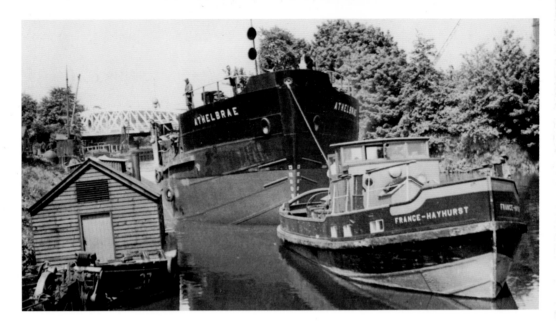

### *France Hayhurst* **Towing** *Athelbrae*

Here we see the tug *France Hayhurst* towing what looks like the new *Athelbrae*. We have already mentioned Northwich's main industry, Brunner Mond (later ICI) but there was another important contribution made in the field of shipbuilding. The first, W. J. Yarwoods & Sons Ltd who from 1896 to 1966 built 1,000 vessels including coasters, tugs, river and canal boats and small military ships (Lawrence of Arabia spent time there in 1934 designing an RAF Rescue craft). Then there was Isaac Pimblott & Sons who also built small river and ocean craft including torpedo boats and other warships in the last war. They traded from 1867 to 1974. Both companies have now gone although their products can still be found around the world.

Looking at these two vessels, *France Hayhurst* was built by Yarwoods in 1938 as a steel motor tug fitted with a Lister engine and was 65 feet long. She was built for the Weaver Navigation Trust and worked on the river for the trust and other owners until the late 1980s. She is currently moored in the Albert Dock at Liverpool.

*Athelbrae* was a steam tanker built at Yarwoods in 1957 for the Athel Line. She was the largest vessel ever to be built on the River Weaver and Athelbrae Close in Northwich is named in her honour. In this photo she will be on the way to a shipyard in Liverpool for repairs. The ship had just been launched on the Weaver and, probably due to her size, the back launching gear collapsed. The ship was supposed to slip into the water sideways, but instead it went bow first. It remained stuck on the slipway for a very short time, but this was enough to twist the ship, needng the repairs prior to trials on the Mersey.

# About the Author

Paul Hurley is a freelance writer, author and is a member of the Society of Authors. He has written a novel and is a columnist for the *Mid Cheshire Independent* newspaper. Other newspaper and magazine credits and a Facebook Group titled Mid Cheshire Through Time that all are welcome to join. Paul lives in Winsford, Cheshire, with his wife Rose. He has two sons and two daughters.

Contact www.paul-hurley.co.uk